John

CW00473417

LIFE, TIMES AND RECORDED WORKS OF

ROBERT DIGHTON (1752–1814)

ACTOR, ARTIST AND PRINTSELLER

AND THREE OF HIS ARTIST SONS

LIFE, TIMES AND RECORDED WORKS OF

ROBERT DIGHTON (1752–1814)
ACTOR, ARTIST AND PRINTSELLER
AND THREE OF HIS ARTIST SONS

PORTRAYERS OF GEORGIAN PAGEANTRY AND WIT

BY

DENNIS ROSE

IN MEMORY OF MY BROTHER, JEFFREY.

Distributed by
ELEMENT BOOKS LTD.,
The Old Brewery, Tisbury,
Salisbury, Wiltshire, England.

Printed by
W. E. BAXTER LTD.,
34-35 High Street, Lewes, Sussex, England.

I.S.B.N. 0 9507579 0 X

LIST OF ILLUSTRATIONS
BY
ROBERT DIGHTON SENIOR

INTRODUCTION AND ACKNOWLEDGEMENTS

As a child I was introduced to the colourful prints of Robert Dighton and his sons: a number of them used to hang in the hall of my mother's house. I had a cousin Frank, almost twenty years my senior, who as an undergraduate, used to buy individual Dighton prints at around five shillings each in Cambridge shops. Gradually he formed a small collection which grew, after many years of browsing through old print folders in London and other places, into a collection of about sixty— mainly of Dighton père but a few of the sons' works also.

Cousin Frank's mother came to console my mother as older sister and stay with her for a couple of weeks after my father's death when I was five years old—and she stayed forty-five years! I owe a lot to my cousin as he became a sort of father to me and it was he who introduced me to the arts and music. Thus I became acquainted at an early age with the works of Dighton and his contemporaries.

When my cousin died he left all his Dighton prints to me and I was able to increase the collection to over one hundred prints by Dighton père (but, alas, only a few nowadays remain with me).

It was some years later that my elder brother and I became interested in all Dighton's works, i.e. not only his engravings but also his water-colour drawings and his prowess as actor/singer at Sadler's Wells. We both visited museums and libraries, and much correspondence took place.

In 1953 there came up for sale at Sotheby's an album of watercolour drawings by Robert Dighton, many of which were the basis for his mezzotints, the artist of which was hitherto unknown. Until 1953 the album had been in the ownership of the Carington Bowles family, the London printsellers and publishers. They had remained almost Dighton's sole publisher until the death of Henry Carington Bowles in 1793. My elder brother and I were determined to buy this collection and after the sale he managed to find enough money to do so. The watercolours were mostly in pristine condition and they covered subjects of a very wide spectrum of life in the late eighteenth and early nineteenth centuries. They were all signed by Robert Dighton and many bore his handwriting in the titles and as notes and remarks for the engravers. After my brother's death the album was sold in 1978 by Sotheby's, being the subject of an entire sale of individual lots.

For many years my brother and I researched the lives of Robert Dighton and his family, and these researches now mainly form the basis of this little book. Until its publication there has only been a limited amount written about this interesting family of artists and actors/singers and I thought that a complete a record as possible of their works and a description of their appearances at Sadler's Wells would be appropriate.

The illustrations here represent only a small fraction of the output of the Dighton family, but the watercolours, in particular, probably portray the most important of their works. It has only been possible here to reproduce four examples in colour but these show admirably the enhanced charm of the artists' skills.

During my researches I received valuable help and encouragement from the late Mr. James Laver (one time Keeper, Departments of Engravings, Illustration and Design, and of Paintings at the Victoria and Albert Museum, author and critic) and also I was able, by the courtesy of the late Librarian of Windsor Castle, Sir Owen Morshead, to examine the Royal Collection of Dightons, one of which is now reproduced in this book by Gracious Permission of Her Majesty The Queen.

My thanks particularly are due to Mr. James Miller and his colleagues at Messrs. Sotheby Parke Bernet for their help and cooperation in arranging for the reproduction of many of the photographs herein. Also to the Curator of the Royal Pavilion, Art Gallery and Museums, Brighton, and to the Sadler's Wells Library.

DENNIS ROSE
October 1981.

LIFE, TIMES AND RECORDED WORKS OF

ROBERT DIGHTON (1752–1814)

ACTOR, ARTIST AND PRINTSELLER

AND THREE OF HIS ARTIST SONS

It is not known what day of the month on which Robert Deighton (he later changed his name to "Dighton") was born, but the year of 1752 is probably correct. If it is correct he came into the world, son of John Deighton, printseller, in the year that was shortened by Act of Parliament by eleven days: for it was enacted that that year, as was the case in most of Europe already, was to begin on 1st January instead of hitherto in previous years on 25th March. The latter date had first marked the beginning of the year when the Gregorian Calendar in 1582 had been introduced to tidy up the errors of the Julian Calendar invented by Julius Caesar.

Whether such tinkering with time had an effect on the personality and character of young Robert, only the astrologers could perhaps decide. Certainly his life-span was to take him through the troubled world from Indian Mutiny, through European and American wars, the French Revolution and the rise and finally almost to the fall of Napoleon. At home he lived in turbulent political times and it was surely his keen observation of the extraordinary extravagances and eccentricities around him, especially in the costume fashions of that era, that provided his ever perceptive eye with the raw material for his artistic creations.

As a boy his father's print shop must have been a big influence in his early life and he was, no doubt, very much acquainted with the caricatures of contemporary artists such as Gillray, Rowlandson, Sayer, Cruikshank and also of course with the great painter and satirist Hogarth.

Robert Dighton first appears as an artistic entity with some small Indian ink, black lead and chalk portraits exhibited at the Society of Artists and the Free Society when he was seventeen and he continued

to exhibit these annually as Mr. Dighton Snr., 66, Fetter Lane until 1774 when his address became "Mr. Dighton at Mr. Glanville's opposite St. Clement's Church". He had entered the Royal Academy Schools in 1772 and from 1775 to 1799 he contributed five portraits and an election scene in Covent Garden (now in the Royal Collection) to the Academy exhibitions. It was evident that in his early work he showed a talent for small neat well executed profiles and in this connection perhaps he was much inspired by the beautiful miniatures of contemporary Richard Cosway of whom he painted a portrait which he called *The Macaroni Painter*. The word "macaroni" was used to refer to the flourish of Georgian dandies wearing towering perukes, diminutive hats, frilled shirt-fronts, with great stock ties and starched high neckcloths, and striped or spotted breeches with beribboned ends. A macaroni club was originally formed by continental travellers, especially to Italy, who wished to boast that they had travelled abroad and had seen these whimsical modes of dress (see page 89). At that time Dighton was living at 266, High Holborn, then in Henrietta Street, Covent Garden and in 1875 in 12, and later in 6, Charing Cross, finally settling in 4, Spring Gardens. It is recorded that at 12 Charing Cross, "such was the gaping crowd that beset the front of his shop, that the passant was always obliged to quit the footway and walk in the road till he had cleared Dighton's premises". Caricatures had become the fashion, not only exhibited in shop windows and sold there, but whole folios of them were hired to amuse the guests by gentlemen who gave parties.

During the time of his exhibitions he styled himself "drawing master" and it seems from an engraving of a self-portrait published by "Bowles and Carver, No. 69 St. Pauls Church Yard London" that he continued to use this title, as he is seen in the engraving holding a large book entitled "A Book of Heads by Robert Dighton—Portrait Painter and Drawing Master". It is interesting to note that in Robert's own hand is written below "Bobby Brush the Phiz-maker" and "May 18 1779" (see page 11).

It was obvious that he had become famous and well-established by the 1790s not only as an artist but also on the stage. His early watercolours (before he changed his name to Dighton) were well executed everyday scenes such as *The Peep Show*. These machines which came from France, were created by Philip de Loutherbourg and caused a considerable stir when first shown in 1781. This watercolour probably shows one of the first in England (see page 45); they were, perhaps, the precursors of "what the butler saw" and other penny peep shows later so prolific on the piers of this country. *A Rose-Seller* accosting a military looking gentleman is also an example of Robert's early attention to detail of the dress of the period (see page 46).

10

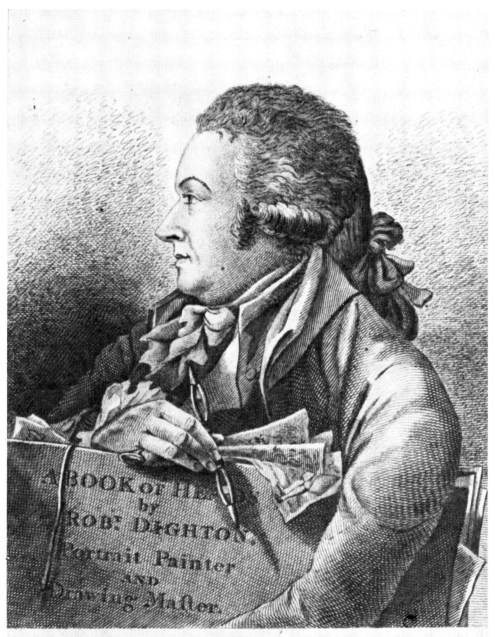

Published by Bowles & Carver N.º 69 St Paul's Church Yard London

A Book of Heads—Self-Portrait.—Engraving.
See page 10.

Robert Dighton must have been a prodigious worker during his early years and it was the stage that, no doubt, started his interest in facial expressions and the study of human nature, as it was later for Toulouse-Lautrec after him.

On many of the theatrical programmes and playbills of Sadler's Wells Theatre the name of "Mr. Deighton" and later "Mr. Dighton", is mentioned. It was apparent that not only was he a good actor but "he was possessed of a very pleasing voice". In 1785 Mr. Dighton, in a preview of the coming season at Sadler's Wells, had been mentioned as follows: ". . . and in the Vocal Line, the well known and admired Mr. Dighton . . .". His first performance at Sadler's Wells was indeed (with Dubois) in 1786 in "The Gates of Calais" and then the same year he sung in "Momus's Gift" (repeated in 1796). With reference to the former, a playbill advertised singing by "Mr. Dighton and Mr. Goldfinch (being their first appearance)"; and a report of the performance stated: "The principal acquisition, however, is Mr. Dighton, who promises to be a support to their burlettas. His character of the friar, in the entertainment of the Gates of Calais, was sustained well, and he gave evident proofs of an excellent bass voice, and a style of acting that must always secure applause". As regards the latter the London Chronicle reported that "Dighton did much credit to the humerous situations of Momus". Then that year his name appeared again with Mr. Goldfinch and Miss Romanzini "in Two new musical pieces for the first time". On 5th June the same year the Morning Chronicle reported a song by Mr. Dighton at Sadler's Wells in honour of the King's birthday:

> "Let Prussia boast her martial King,
> And men of giants size;
> Frenchmen of their Monarch sing,
> And all their baubles prize;
> 'Tis George demands a Briton's song,
> To whom the virtues all belong.
>
> The Father not the King appears
> O'er British hearts to sway,
> And sacred through revolving years
> Be this auspicious day;
> 'Tis George demands a Briton's song,
> To whom the virtues all belong."

In August 1787 a playbill announced "The public are most respectfully informed that by very particular desire, the address which was delivered by Mr. Dighton on this night and which was received with the most distinguished marks of approbation by a very numerous and polite

audience, will be repeated this evening for the last time". That year he appeared in "Hooly and Fairly or The Highland Laddie and the Old Witch", a part which later became the subject of one of his watercolour drawings (see page 79).

In 1788 his name appeared in "Merlin's Cave or A Cure for a Scold", repeated later in 1790. The song he sang went as follows:

"There was a Master Taylor
Who liv'd in Golden-lane,
Who married to a scolding wife,
Who gave him mickle pain;
Full patiently he bore it
Three quarters of a year,
And that that happen'd afterwards
Attend, and you shall hear.
 Tol de rol, rol de ra, &c.

One morning pretty early
She 'gan to play her part,
While Snippy found that all words
Were bodkins at his heart.
Says he, my dear, 'tis pity,
So good a wife you are
You ne'er was measured for a vest,
Which all good wives should wear.
 Tol de rol &c.

This garment will become you,
And wear uncommon tough,
Good temper in this lining,
Good words the outside stuff.
Have but a little patience,
I'll fit you in a crack
Then flourishing his yard wand,
He laid it cross her back.
 Tol de rol &c.

So like a cleaver workman
He winded her about
There wa'nt a corner in her shapes,
But snippy found it out.
She grumbled at her trimmings,
Yet ne'er a word but—mum;
Because the Taylor's wand,
Was the thickness of his thumb."

In 1789 Mr. Dighton performed in "The Female Soldier", "The Witch of the Lakes or Harlequin in the Hebrides" (repeated in 1793) and in "The Two little Savoyards". In the following year, 1790, his name appears under performers and singers in "The Incas of Peru or The Children of the Sun"—"as performed last season in Paris, for ninety-nights, with entire new dresses, decorations and original French musick". Then that same year he sang in "The Champ de Mars" and in "The Guardian Frigate". The latter was billed as "an admired Historical Representation, in Two Parts, in which is correctly given a Living Picture of the Guardian Frigate with Lieut. Riou and his Crew in their very Perilous Situation embayed among the Stupendous FLOATING ICE ISLANDS in the South Seas". Dighton did a vivid watercolour drawing of this rescue (see page 51) and the story has been told as follows:

"The Guardian, a British 44-gun transport, sailed from Spithead in September 1789 with stores and convicts for the newly founded colony in New South Wales. It put into Table Bay on 24th November and took on a cargo of livestock and grain destined for the new settlement. Leaving Cape Town on 11th December she hit 'an island of ice' (Comm. Riou Log) on 22nd, 1,200 miles from Cape Town. After vainly attempting for four days to render the vessel sea-worthy, the commander, Lieutenant Riou, ordered the four boats to be launched and about fifty-six of the crew and convicts, including Mr. Clements, were embarked in them. The latter, with fourteen men, was in a launch picked up on 3rd January 1790 by a French merchantman, the Vicomtesse de Bantannie, and they eventually reached Table Bay on 18th; nothing was ever heard of the other boats. Lieutenant Riou, with about seventy convicts and officers bound for Botany Bay, remained on board The Guardian. To lighten the vessel they threw overboard the heavy guns and livestock and succeeded in keeping the boat afloat until she was observed by a Dutch packet boat, with whose assistance she was taken into Table Bay on 21st February where she was beached and soon became a complete wreck". Commander Riou is described as being "one of the most elegant men, tall, well made, with a face of much dignity, which indicates all the heroism he displayed". It is recorded that Edward Riou became a Captain in the Royal Navy in 1791, led the detached squadron against the defences of Copenhagen, where he was killed by a cannon-shot in 1801. Nelson knew him well and had an affectionate regard for him. After Riou's death Nelson wrote "In poor dear Riou the country has sustained an irreparable loss", and Parliament voted a monument to him in St. Paul's.

The year 1792 seems to have been a very busy year for Dighton at Sadler's Wells and it was during this year that "Mrs. Dighton" also appeared with her husband in several performances. First, she appeared

in April with her husband in "Queen Dido or The Trojan Ramblers" after he had appeared with others in "The Coquette" on the same evening. Then in June they appeared together with others in "An Allegorical Divertisement of Songs, Duets and Recitatives". In July they were together in "The Fortune Hunters or You May Say That", followed, in September, in "The New Prussian Manual" when, the same evening he also appeared with Mr. Dubois in "All's Not Gold that Glitters". In October he was in his perhaps most famous role of "Dennis O'Neal" in "Dennis O'Neal's Return from Campaigning" which was billed as "A Comic Vocal Effort", being a New Nabobish Chaunt in Anglo-East-Indian-Irish called "Planxity Na-Bock-Lesh"! (see page 16). Then in September Dighton performed in "The Artillery Driver" when a critic stated "Dighton has gained a most capital addition to his fame as a comic singer in the last chaunt of 'The Artillery Driver'." In 1793 he was in "The Prize of Industry or The Village Rejoicing Day" and again in "Witch of the Lakes", followed in 1794 by "The Village Ghost".

After a repeat performance in "Momus's Gift" in 1795 he appeared in "Gaffer's Mistake" with Thomas Dibdin (being the latter's first appearance on the stage) and Mrs. Dibdin and, in the following year, sang "the favourite new song of The Irish Newsman" which went as follows:

"You may sing of your wagoners, ploughboys, and watchmen,
　　Your Lamplighters, sailors, and pedling jews,
There's no trade like mine, for you're sure to catch men,
　　Rich, poor, old and ugly, all rading the news;
While round with my papers strait forward I'm going,
　　My masters they find me employment enough,
For we make out the bus'ness by puffing and blowing,
　　My master's horns after blowing whatever they puff,
And between us both we contrive to
　　Botheroo! ditheroo! merry and frisky,
My horn always made as much noise as he cou'd,
　　For as sure as dear Dublin's the country for whisky,
It must be an ill wind that blows nobody good.

If our oracle ever shou'd fail, tis no wonder
　　The Times are complain'd of as not always right,
And sometimes the Sun, just by way of a blunder,
　　He sets in the morning and rises at night;
Then twould puzzle your worships my plan to unlock it,
　　How often I travel regardless of harm,
With a Star in my hand, and The World in my pocket,
　　And carry a Telegraph under my arm.
And then you see I'm like the Public Ledger, open to
　　All parties and influenced by none, and that's the
Way I botheroo, ditheroo &c.

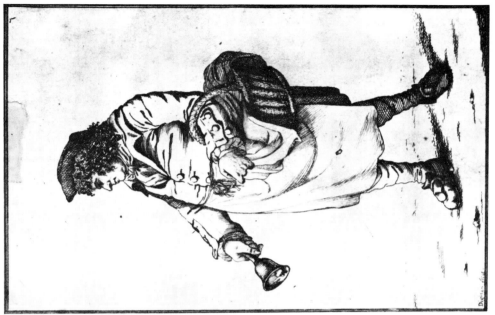

Robert Dighton in the Character of the Muffin Man.
—Engraving. (Courtesy of Sadler's Wells Library.)
See page 17.

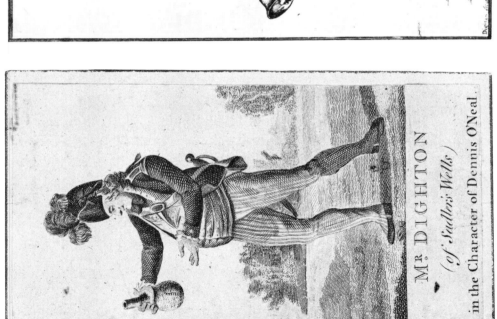

Mr. DIGHTON
(*of Sadler's Wells*)
in the Character of Dennis O'Neal.

Robert Dighton as Dennis O'Neal at Sadler's
Wells.—Engraving. (Courtesy of Sadler's Wells
Library.) *See page 15.*

Then I've all the agraable news of the nation,
Your battles and murders, and such pretty jokes,
Wid your parliament spaaches, agrah! botheration,
And the nate little things that are done by grate folks,
Then I lump every accident, death or promotion,
Your tragedies, comedies, all in a string,
Wid wedlock and hanging, for some have a notion
That one thing and t'other is just the same thing.
And by my conscience I think so myself for a man
Had better be tuck'd up at once than plagu'd with
A perpetual botheroo, ditheroo &c.

The song was published under a sketched head of Dighton and sold by J. Evans, No. 41, Long-lane.

It is interesting to note that on the actual Sadler's Wells playbill the following were the prices of the various seats in the theatre: "Boxes 4s. — Pit 2s. — Gallery 1s. — No money to be returned. Doors to be opened at Half-past Five o'Clock, and begin at Half-past Six — Servants to keep Places till Half-past Seven".

After Dighton had appeared in a sketch in 1797 at Sadler's Wells, entitled "Mr. Dighton in the Character of the Muffin Man" (see page 16) he apparently gave up the stage and advertised his prowess as drawing master and portrait painter in order to redouble his efforts to procure more work. His stage successes, no doubt, helped in this respect, but not all the theatrical critics approved of his earlier endeavours on the stage, it seems. However, the following criticism at the start of his career at Sadler's Wells at least showed promise: "This gentleman was the son of a respectable tradesman in London, who having taken a liking to the stage, procured an engagement at Sadler's Wells, which seems to be the chief of his ambition; yet we must confess, that many of inferior merit have an established engagement at the regular theatres. Mr. Dighton is possessed of both a good voice and proper delivery: we cannot say, indeed, if he were taken out of his recitative acting, how he would acquit himself; but it is really astonishing that, like other Thespian sons, he is not more aspiring! He sings an Irish song with almost as much humour and propriety as Mr. Johnstone". Perhaps this critic was well and truly reassured a few years later!

Two stories are recorded about Robert Dighton, the actor. First, an extract from the diary of a man up from Wales in 1794 (Burletta Writer) is as follows: ". . . and I was told that if I called on Mr. Robert Dighton at Charing Cross, I should certainly 'hear of something to my advantage'. This, however, when I did hear of it, implied 'work hard, be very careful

and you will be well paid'. Dighton next night took me to the Wells. 'The Rival Loyalists or Shelah's Choice'. Principal part by Dighton. I was paid five guineas"—a great deal of money in those days.

The second story was told as follows: "Being somewhat involved (a sad misfortune attending the generality of theatrical heroes) and dreading the salute of a bailiff, previous to his benefit, in order to enter the theatre without interruption, and entertain his friends, who were very numerous indeed on the occasion, he prevailed upon a brewer to suffer him to be rolled into the house in one of his barrels. The gentlemen on the look-out were rather suspicious, and apprehended the trick; they stopped the driver, and challenged his barrels; but the man being shrewd and resolute, dared them to meddle with one of them, by which means Mr. Dighton was rolled in with the greatest safety, and no small entertainment of the Thespian Crew".

By the turn of the century, although his artistic works had become as well-known as his antics at Sadler's Wells it seems that Dighton was in and out of trouble financially and it was, no doubt, this that led him to advertise his availability as an artist in various journals and later to commit a series of desperate and damaging follies at the British Museum from which he was slow to recover.

In 1798 he advertised as follows in the "Morning Chronicle": "CORRECT LIKENESS. Mr. Dighton, No. 12 Charing Cross informs the Public that he continues to take correct elegant likenesses in miniature for half a guinea, in half an hour and in a manner peculiar to himself; and which have given such universal satisfaction to his employers. They are adapted for a frame or to set in a locket. He takes the whole length figure in the same manner with appropriate room, garden or landscape, for two guineas, frames included. Mr. Dighton will attend any distance under ten miles to take likenesses (not less than four)".

It must be remembered that there was, towards the end of the eighteenth century, much competition for artists in the field of caricature and small satirical portraiture, and the prices obtained by such an aspiring artist as Dighton were usually very small indeed. At Sadler's Wells, also, he probably earned very little for his hard work, and so it always must have been difficult to make ends meet, particularly if he was a spender too. A hard worker he surely was but no doubt was greatly influenced by his father and the good-living circle of influential friends in which the latter moved. It is known, for example, that father and son were both members of the "Court of Equity" at the Belle Savage

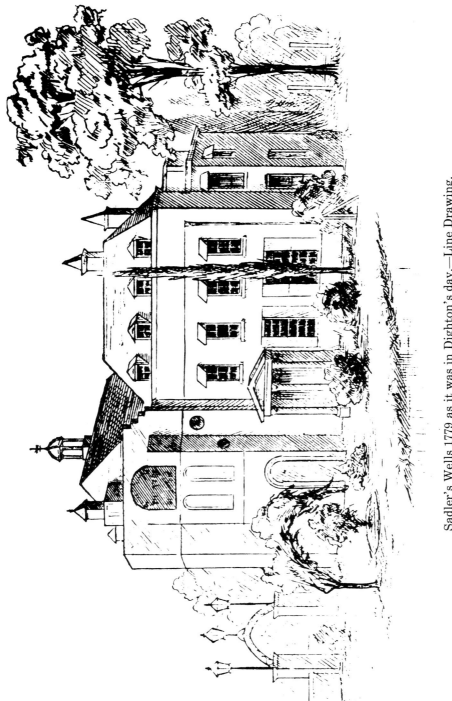

Sadler's Wells 1779 as it was in Dighton's day.—Line Drawing.
(Courtesy of Sadler's Wells Library.)

19

Inn at Ludgate Hill where Dighton fils painted a picture in 1778 at a meeting of the various members of the Society. An engraving of it was made by John Smith of Cheapside (see page 47) and in addition to the Dightons the names of the other members present appear below the print. The members met to drink punch, smoke and talk together, and came from all walks of life. Included in the picture were a distiller of Fleet Street, the clerk to the printer of the Morning Chronicle, another printseller, a sausage maker, an attorney, a bricklayer, a broker, and an auctioneer.

At the same time that Robert Dighton was appearing at Sadler's Wells he was producing large quantities of drawings and watercolours, some of which reflected performances at Sadler's Wells and from many of which mezzotints and other engravings were made. He evolved the idea of a full-length portrait at the same time both humerous and decorative, yet usually not following quite such a grotesque style as perhaps Hogarth or Gillray. His own particular style and tone of humour made so attractive his etchings of noble, military, university, sport and, of course, stage personalities. The law and the church were also included in his portrait repertoire and he also produced a series of prints of personalities of the day taken on the "Steyne" at Brighton and in the Pump Room at Bath. It seems that almost nobody who was anybody was forgotten—Mr. Richard Tattersall and the celebrated first Mr. Christie, the auctioneer, who was shown as *The Specious Orator* selling "a brilliant of the first water" (the head of this engraving is a basis of the logo used by Christie's on their catalogues). Nearly all had humerous titles, were signed and coloured. One of the earliest of these engravings dated 1793 was entitled *A Jack in Office,* Mr. William Jackson—Commissioner for Excise (see page 48).

Of his series of stage personalities in costumes of the parts they were playing, many of the famous actors and actresses of the period were included, e.g. Mrs. Siddons as *Elvira* in "Pizarro" and her actor brother John Kemble also in "Pizarro"; another brother Stephen Kemble as *Hamlet* (the latter was the actor manager who, all 18 stone of him, played Falstaff without padding) and Mr. Braham in *Orlando*. These subjects for portraiture were stars of stage, and they and the great song-writers Charles (whose songs, it is said, helped to win the Battle of Trafalgar) and Thomas Dibdin were the great inspiration for an aspiring actor-singer such as the young Robert Dighton. Not only was Charles Dibdin a composer but he was also entrepreneur; and many of the characters from his popular songs were drawn by Dighton, e.g. *Poor Jack* which commemorated the death at sea of Captain Thomas Dibdin (see page 50), Charles's brother, the *Artillery Driver* and *The Lamplighter*.

The *Artillery Driver* (see page 54) depicts a yokel waggoner wearing a military hat. He stands in front of the Prince of Wales's tent and a cannon on Bagshot Heath where military reviews took place in July and August 1792, supported by the Prince of Wales and the Dukes of York and Cambridge.

> "I was once a waggoner Shy and Dry,
> And ever jog'd over the Downs,
> And no market crop was known better than I
> In the neighbouring country towns.
> But hating a tiresome lazy life
> And fearless of wounds and Death—
> I set out on a tramp to follow the Camp—
> And drive to the jig of a drum and a fife
> King's cattle on Bagshot heath . . ."

New manoeuvring techniques were tried out on Bagshot Heath and the marching without any particular purpose was made famous in the lampoon on the Duke of York.

> ". . . had ten thousand men,
> He marched them up to the top of the hill,
> And marched them down again."

The Lamplighter watercolour (see page 56) was based on:

> "I'm Jolly Dick the Lamplighter.
> Rogues, Owls, Bats can't bear the light
> I've heard your wise ones say;
> And so, d'ye mind, I sees, at night
> Things never seen by day . . ."

His watercolour of *Bachelor's Hall* (see page 73) was also an illustration of Charles Dibdin's song.

> "To Bachelor's Hall we good fellows invite
> To partake of the Chase that makes up your delight.
> We have Spirits like fire, and of health such a stock
> That our pulse strikes the seconds as true as a rock."

Amongst his political works it was the *Peace of Paris* (The Treaty of Versailles) which inspired Dighton to produce *Intelligence on the Peace* (see page 83). Although the peace to end the American War of Independence had been concluded on the 9th September 1783 it was not formally proclaimed in London till the 6th October. In the watercolour a cobbler in a City street, reading from the "Gazette", tells the news to a group of tradesmen which includes a chimney sweep, a barber, a carrier and a street oil lamp repairer with his assistant.

A set of twelve watercolours, annotated in Dighton's hand, were also produced as illustrations for "Tristram Shandy" which he called *Twelve Drawings Representing the Most Interesting, Sentimental, and Humorous Scenes, in Tristram Shandy*. Two of these are reproduced in this book (see page 82):

> "Uncle Toby and the Widow Wadman—with a mote in her Eye—a mote or sand or something—I know not what—has got into this Eye of mine—do look into it—it is not in the white—" and "Tristram Shandy discovering Maria.—And who is this poor Maria—Said I—The love and pity of all the villages around us—said the postilion— It is but three years ago—the sun did not shine on so fair—so quick witted—and amiable a maid—"

Dighton also drew vivid facial expressions of audiences both inside and outside the theatre, e.g. *The Pit Door* (see page 57) outside which can be seen evidence of the overcrowding at Drury Lane, long complained of (on the wall is posted evidence that it was the occasion of a Royal Command Performance, when Mrs. Siddons was in her most famous part of "The Grecian Daughter" and Mr. Kemble, her brother, is advertised in "Hamlet" for the next evening), and "At a Tragedy" and "At a Comedy".

In 1794 he produced a set of 12 mezzotints of the months showing the appropriate costume for each month, and a small coloured and engraved "Droll Caricature map or Geography Bewitched" map of England and Wales, and also a similar one of Scotland. A third, added later, of Ireland was inscribed "This portrait of Lady Hibernia Bull is humbly dedicated to her husband the great Mr. John Bull" (see pages 62 and 63).

Many of Dighton's works have long been known, but it was not until 1953 that a hitherto unknown volume suddenly came up for sale at Sotheby's and appeared again in the same saleroom in 1978 at which latter sale the album was split up and the watercolours dispersed, several going to the United States. This volume had until then belonged to the Carington Bowles family who, except for Dighton himself later, it seems, were with Bowles and Carver the main publishers of Dighton's engraved works as successor to John Collett who died in 1780. Dighton's many mezzotints, mostly produced and published without a name or signature in the early days, were comparatively well-known after his death, but the identity of the artist had been doubtful.

Some of the coloured mezzotints of the 1780s and 1790s showed harsh colouring and a rather clumsy style at the beginning of the period, but gradually it can be seen that his style developed and changed to a far more meticulous development of detail and especially of colour. This is

22

underlined by the diverse collection in the new-found Carington Bowles volume containing the long "lost" watercolour drawings which were bound into this album by the Carington Bowles family *circa* 1830. The album contained 128 watercolour drawings and 21 in indian-ink wash. Most of them were signed R. Dighton on 18th century wove paper, and titles were inscribed in his own hand. Also many of them had alteration instructions written by Dighton for engraving into the mezzotints.

He liked to poke fun at his subjects and underlined his satirical bent by using puns in many of his captions underneath the portraits. Naval and military subjects, London life and country pursuits were all included in the album: barbers, dentists, parsons, the legal and medical professions, milliners and harlots were all subjects for witty comments. Refugees from the French Revolution were not excluded and he depicted a group of six French émigrés having just escaped from the Revolution to find themselves stranded at Dover (see page 69). The attempted assassination of George III on 2nd August 1786 at the garden entrance to St. James's Palace (see page 64) and a second attempt later at Drury Lane on 15th May 1800 were also depicted. (He later (see page 65) also produced a portrait of the King in honour of his jubilee at the age of seventy-two.) It is interesting to note that the poor insane assailant of the first attempted assassination, Margaret Nicholson, who tried to stab him with a knife whilst holding a petition in the other hand, was spared by the express orders of the King and spent the rest of her life until 1828 in the "Bedlam" institution (the "Bethlehem Royal Hospital").

Portraits of the Prince Regent wearing the Garter Star on a blue coat (see page 49) and the Duke of York in the uniform of the Coldstream Guards, also wearing the Garter Star (see page 55), were both included in the album of watercolours and there were even two self-portraits of Dighton himself, one entitled *I'm the Thing, An't I?* This latter self-portrait showed Dighton dressed up in dandyish garb that probably represented one of his parts on the stage (see page 49). Also in the album Dighton portrayed *Molly Milton, the Pretty Oyster Woman* (see page 60), a popular song sung at Sadler's Wells by Mrs. Jordan, friend of the Duke of Clarence. The costumes are drawn and coloured with great attention to detail.

The watercolour entitled *A Glee. Une Allégresse* (see page 80) is a humorous description of the Glee Club which used to meet in Mr. Robert Smith's house in St. Paul's Church Yard where Dighton's publishers had their offices. The Glee Club used to meet informally from 1783 until it was founded officially in 1787. At the club's meetings the members sang glees, catches and canons between the drinking of wine punch. A good time was had by all. It was probably Dighton's involvement with the theatre that introduced him to the club.

The Return from a Masquerade—a Morning Scene (see page 81) shows two grinning chairmen carrying a pale-faced and sleepy lady dressed as a shepherdess coming home in the early hours from a ball. A small chimney sweep holds her mask.

George Dance Junior's Newgate Prison was completed in 1778 (now the site of the Old Bailey). In *A Fleet of Transports under Convoy* (see page 86) a group of convicts are being led past the Prison on their way to transportation. It is interesting to note that when transportation came, temporarily, to an end in the early 1780s, hulks in the Thames were used as a substitute.

Another subject was *John Gilpin's Return from Ware, Hertfordshire* (see page 67).

"Away went Gilpin and away went Gilpin's hat and wig" when he decided to celebrate his twentieth wedding day with his wife and family at the Bell at Edmonton, Middlesex. He lost control of his borrowed horse which carried him a further ten miles to Ware, before returning towards Edmonton but, failing to halt there, was carried straight on back to Cheapside.

Dighton made two watercolour illustrations to Sheridan's "Duenna" (see page 72).

"See with these friars how religion thrives
Who love good living, better than good lives . . ."

In 1757, a Mr. Hughes discovered mineral springs at Battle Bridge near Kings Cross, one chalybeate and one purgative, and soon the springs were called St. Chad's Wells. They were developed by Dr. John Bevis and became the popular pump rooms of Bagnigge Wells where, combined with drinking the waters people were able to stroll by the river Fleet past shell grottoes and shady arbours. It was probably Hogarth's "Evening" that inspired Robert Dighton's composition of *Mr. Deputy Dumpling and his Family enjoying a Summer afternoon at Bagnigge Wells* (see page 75).

Scotland was not forgotten when Dighton depicted in *Hooly and Fairly* (see page 79) an old Scot complaining of his drunken wife who can be seen in the background holding up a tankard and a bottle at her feet whilst another kinsman tends to the horse and cattle.

24

It was intended to illustrate an old Scottish song:

"Oh what had I ado for to marry
 My wife she drinks naithing but Sach and Canary
 I to her friends complain'd right airy
 O' gin my wife wad drink Hooly and Fairly."

Then followed eight more verses telling of his wife's intemperance.

Dighton's skill as a draughtsman is admirably demonstrated in his architectural study of *A South View of the Church of St. Pancras in the County of Middlesex* (see page 66).

In spite of giving an impression to his public of living in the grand manner, Dighton was often short of cash. He was, it seems, somewhat of an art-collector himself and, no doubt, this was the cause of much of his spending whilst being continually in debt. During the time of his most prolific enterprises both on the stage and as artist he collected engravings and etchings. Indeed, he was always on the look-out for anything to his taste to supplement his collection. In 1794, it is recorded, he went to the Print Room of the British Museum and there began a friendship with Mr. Belloe, an under-librarian, who introduced Dighton to his daughter. One day Dighton made a present to her of a portrait of himself and Miss Belloe which was gratefully received. He continued his visits to the Print Room at frequent intervals and on these occasions always carried a portfolio into which he used to transfer, unobserved, prints from the Museum folio. It was not until 1806 that the thefts were traced to him when he sold to a dealer, Samuel Woodburn, for £10 an excellent copy, which he had made himself at home, of a well-known Rembrandt landscape engraving known as "The Coach Landscape". Woodburn, elated by his latest acquisition, showed it to a friend who told him that, in his opinion, it was a forgery as he knew that the only copy was in the British Museum. After much argument the two went to the Print Room and, as a result, the theft was easily traced to Dighton who then confessed to stealing a number of others which were later found and all returned. This caused somewhat of a scandal but it appears that Dighton received no serious punishment, whereas the obliging Mr. Belloe lost his job. But punished he was, for he was apparently compelled to flee from London at the risk of being shunned by both his clients and his friends. So, for the next few years he stayed in Oxford, Cambridge and Bath and produced rather repetitive full-length slightly satirical portraits of dons of both universities and of personalities at the Pump Room in Bath. In 1810 he, apparently, returned from his self-exile from London and set to work in his own printing press with his young sons at Spring Gardens. In 1810 he did his portrait of the King at Windsor so, perhaps, once more he was received and acclaimed in the

right quarters, but once again he was, it seems, in financial difficulties: for he wrote a letter on 22nd October 1812 referring to "his pecuniary embarrassment" and "age has impaired my abilities as an artist very considerably". In this letter he also refers to "the hardness of the times (not extravagance—as can be well attested)" and, the letter, in his own handwriting, is written to try to obtain a job on the stage for his daughter, Sarah (see page 27).

It was Sarah, his only daughter, whom in 1800 he had portrayed as *My Dear Girl;* and when her father died in 1814 at Spring Gardens the Consistory Court of London granted administration of his estate, and all his goods, chattels and credits to Sarah Burnell (wife of Thomas Burnell, architect of 46, Chancery Lane), "the natural and lawful daughter and only next of kin of the said deceased".

This latter document is of considerable interest for it appears that Robert Dighton had three sons (and possibly a fourth, Joshua), all still living in 1814, and this points to the fact that they were not his sons conceived in marriage, but were probably illegitimate. Nothing seems to be known about his wife other than the fact that her name appeared on various playbills with her husband at Sadler's Wells.

All the sons tried their hands as artists and all with varying degrees of success, but none of them showed, for the most part, the delicate draughtsmanship of their father, whose importance in recording the social and political history of the era should not be underestimated. Above all, he loved to poke fun at life—albeit on most occasions politely and without rancour. He must surely be considered also as taking a major part in the transition from caricature to perhaps more subtle and witty, yet relatively dignified full-length portraiture which his sons endeavoured to emulate and which lasted through the era of the "Vanity Fair" cartoons and well into the age of photography.

His eldest "son", Robert Dighton Junior, was born in 1786 and followed an army career, for records show that he was appointed Ensign in the West Norfolk Militia in 1808 and transferred to the 38th Foot Regiment in 1809. During his time in the Army he was able to observe the various uniforms and customs of the Regiments and, no doubt under guidance of and published by, his illustrious father, he drew many portraits from life. These coloured drawings and engravings form a large part of the Dighton examples in the Royal Collection at Windsor Castle. For the most part they are signed "Dighton Jun." or R. Dighton, Jun. and about half are undated. The earliest date is, however, 1800 and this makes Robert Junior only fourteen years old at this date. These portrait examples are mostly of different style to his father's and their execution

4 = Spring Gardens – Charing Cross –
Oct.r 22.1812.

Sir

Tho' I have not the Honor of being known to you
personally – the name of Dighton – as an Artist – you
may have heard of – I have an affectionate Daughter
who has very promising theatrical abilities – she
has strong powers and sings well – She wishes most
earnestly to make an effort on the Stage – by which
she might obtain the power of assisting me in my
present pecuniary embarasment – Age has im-
-pair'd my abilities – as an Artist very considerably,
I have a large family – and the hardness of the
times (not extravagance – as can be well attested)
press on me very heavily – My dear girl is
very ardent in her hopes & wishes to accomplish
something for the relief of her family – I humbly
entreat your kind interference – as you will
thereby give happiness to us All – She is a
virtuous good girl – which I am sure will have
great weight with a man of your excellent prin-
-ciples – Pray Sir forgive this intrusion – which
nothing but sad necessity – wou'd have urg'd me
to do – I have the honor to be yr Obed.t Hble Serv.t
Rob.t Dighton

Letter dated 22nd October 1812 in Robert Dighton's own hand.
See page 26.

is generally very much inferior. It is, however, just possible that his father or one of his brothers may have been responsible for some of these. Certainly, Robert Junior had comparatively little success compared not only with his father but also with his two younger brothers, Denis and Richard. However, whilst in the army he served in India and in the Peninsula; and in 1814 he produced an engraving of the Duke of Wellington at Elvas, Portugal, which was probably one of his last works, if not his last. He retired from the army in 1834 and perhaps from childhood he had been fascinated with all things military so that he was determined from an early age to make the army his career. He died in 1865.

Denis Dighton was the second "son" and was born in 1792. He somehow caught the attention of the Prince of Wales, and through him in 1811 obtained a commission in the army in the 90th of Foot, but resigned a year later. He, too, tried his hand at full-length portraiture, but he also exhibited a few larger paintings of battle scenes at the Royal Academy between 1811 and 1825. After he had resigned his commission in the army he devoted his life to art and in 1815 he was appointed Battle Painter and Military Draughtsman to the Prince of Wales. He produced a large number of watercolour drawings of which there exists in the Royal Collection at Windsor 243 and more than 150 pencil monochrome drawings. It seems that he visited Waterloo a few days after the Battle and made 9 drawings. His works, although executed with bravura, show that the artist often gave way to phantasy, but in the main they make a pleasing and interesting account of military history. At times he was remarkably accurate in his details of uniforms and sometimes also in facial expressions. This accurate detail can also be seen in his oil painting at the National Maritime Museum, Greenwich, entitled *Nelson Falling: Mortally Wounded at Trafalgar* and in his watercolour of *George IV's Coronation Banquet Champion* (see page 92) in the Royal Collection at Windsor. Eventually, it appears, he lost the royal patronage and died in 1827 of mental derangement at St. Servan in Brittany. His wife was also an artist and became Fruit and Flower Painter to Queen Adelaide. She exhibited between 1841 and 1854 at the Royal Academy and later married a Mr. McIntyre.

Perhaps not quite so prolific as his elder brother Denis, Richard, who was born in 1795, soon made a name for himself. He mostly followed in his father's footsteps and began in 1815 and 1816 with four plates from Oxford and Cambridge, and one from the bar. He then produced many rather stiff looking full-length side-view portraits of City characters, characters at "the West End of the Town of London" (see pages 90 and 91) and also of a few prominent actors and actresses. He also produced two coloured engravings containing in miniature the heads and

shoulders of many of the well-known personalities about town in 1818 and 1819 (see page 89). He continued drawing rather stilted full-length profiles until 1857 or later and he died in London in 1880 at the age of eighty-five. He, like his elder brothers, had had a spell in the army (he was an officer in the Worcestershire Yeomanry *circa* 1834) and during this time, no doubt, he executed 34 portrait drawings of British Officers which are in the Royal Collection.

It is possible that Joshua Dighton was a fourth "son". He produced sporting caricatures from the 1820s to the 1840s.

The following lists of known works of Robert Dighton and "sons" will not contain all their artistic creations but are, it is hoped, comprehensive enough to be a useful record of most of them.

ROBERT DIGHTON SENIOR

Watercolour Drawings
Miscellaneous—Town and Country
The Peep Show
A Rose-Seller
A Lady Marketting
The Reward of Virtue
Dr. William Layton—(1794)—Veterinary Surgeon to George III and IV
A Sportsman and his Wife (1791)
Comme ce corse nous mène (There is gallantry for you)
John Kemble
Mr. Quick as Isaac Mendoza in the Duenna
Mr. Booth (1790) as Father Luke in "The Poor Sailor"
Mr. Parsons as Money Trap in "The Confederacy"
Mr. Robert Bensley as Prospero in "The Tempest"
Mr. J. W. Dodd as Sparkish in "The Country Girl"
Court of Equity at the Belle Savage Inn, Ludgate Hill—(1778)*
The Macaroni Painter (Richard Cosway)
Assassination attempt on George III at Drury Lane, 15th May 1800
Glee Singers executing a Catch
Men of War bound for the Port of Pleasure

A collection now dispersed from the Carington Bowles family album after sale at Sotheby's on 23rd February 1978. Many of these had also been made into mezzotints.

The Harmony of Courtship; The Discord of Matrimony
The First Interview or Happiness Sacrific'd to Riches
The Lottery Contrast
Spring and Winter
A Courting Couple
A Deep One—Mr. Mathew
A Sour Dog or Brought to trouble and woe by cards, dice and E.O.
A Knowing One
Choice of Fruit Sir
A Connoisseur
I'm The Thing, An't I
I'm Ready For You

*An engraving was made and persons named. Robert Dighton and his father John Dighton appear.

Hooly and Fairly
Youth and Age
Intelligence on The Peace
I say Nothing—I smell a Rat
I have got de Monish
We're all in the Suds
The Lady's Plaything—A Guinea Pig
A Lesson Westward—Or A Morning Visit to Betsy Cole
A Drap of Whisky
A Puppy's Dress in the Dog-Days
Lame Duck
He-He-He- I loves Fun
Well! I can't help it
The Frenchman in Distress
Mr. Deputy Dumpling and Family Enjoying a Summer Afternoon
A Fleet of Transports under Convoy
Labour in Vain—or Fatty in Distress
A South View of the Church of St. Pancras in the County of Middlesex
Taking a Walk
Looking at the Monuments
An Army Officer, A Milkmaid, A Beggar and a Horseman on the Road
 by a Farm
A Carter Getting Ready
A Lady and her Child walking through a Village with her Dogs
Drawing Water from the Village Well
A Country Maid Feeding the Chickens
A Jolly Farmer Crossing a Yard
A Gentleman and his Two Children walking round his Farm
A Gentleman taking Ale at The Wheatsheaf
A Landowner Visiting One of his Farms
A Pedlar Trudging past a Farm
The Village Pond
Flying a Kite
Twelve Illustrations to Contemporary Life and Diversions

Politics
Portrait of H.R.H. Prince George, The Prince Regent
Margaret Nicholson's Attempt on the Life of George III—2nd August
 1786
In Place
Out of Place
Intelligence on the Change of Ministry
French Privateers. Cruising in the English Channel
An Aristocrat
A Democrat

Here's a Health for the Duchess of York wherever she goes
Tippy Bob—The Natty Crop
Margaret Nicholson attempting to Assassinate George III at the Garden
 Entrance to St. James's Palace—2nd August 1786
Three Election Scenes (1784, 1788 and 1796)

The Church

Death and Life Contrasted or An Essay on Man
Life and Death Contrasted or An Essay on Woman
A Journeyman Parson going on Duty
A Master Parson's Return from Duty
Industry Produceth Wealth
The Prodigal Son taking his Leave
The Prodigal Son Revelling with Harlots
The Prodigal Son in Misery
The Prodigal Son Returned Home Reclaimed
A Master Parson with a good Living
A Journeyman Parson with a bare Existence
Father Paul in his Cups or, The Private Devotions of a Convent
Father Paul Disturbed or, The Lay Brother Reprov'd

Sporting Subjects

A Hunter taking a Flying Leap
The Return from the Sports of the Field
Rubbing Down after a Fox Chase
The Squire Thrown Out
Bachelor's Hall
The Pointers on Scent
Earthing the Fox
Pheasant Shooting
Snipe Shooting
Tally Ho
Coursing the Hare
Death of the Hare
Setting Dog And Partridges
Partridge Shooting
A Horse Dealer Selling a Nag
Youthful Sport

Trades and Professions

Quarrelsome Tailors, or, Two of a Trade Seldom Agree
Molly Milton, The Pretty Oyster Woman
The Barber Riding to Margate
The London Dentist

How Merrily We live that Doctor's be we Humbug the Public and Pocket
 the Fee
A Morning Ramble, or The Milliner's Shop
A Sharp between Two Flats
The First Day of Term or, The Devil among the Lawyers
A Bailiff and an Attorney—A Match for the Devil
Term Time or The Lawyers all alive in Westminster Hall
Lord Loughborough
Sir James Eyre
Sir Archibald Macdonald

Literary, Musical and Theatrical
The Pit Door
Tragedy Burlesqued, or The Barber Turned Actor
The Lamplighter
The Return from a Masquerade—A Morning Scene
Myself
A Glee. Une Allégresse
Love in a Village
Charles Dibdin
Twelve drawings representing the most interesting, sentimental and
 humorous scenes in "Tristram Shandy"
At Loss for a Thought—Poor Author
The Man of Letters or Pierot's Alphabet
Pierot's Numerals
John Gilpin's Return from Ware, Hertfordshire
H.R.H. Frederick, Duke of York
The Artillery Driver
The Duke of York
Lady Gorget Raising Recruits for Cox Heath
The Banks of the Shannon or, Teddy and Patty
An English Man of War Taking a French Privateer
An English Sloop Engaging a Dutch Man of War
The Perilous Situation of "The Guardian" Frigate
Sailors Riding to Portsmouth
The True British Tar
Poor Jack
A Rich Privateer brought safe into Port, by Two First Rates
The Contrast

*Miscellaneous—Album at Ashmolean Museum, Oxford, containing
watercolours by the Dighton Family*
Betting on a Horse Race
A Peep into Westminster Hall

Scene in a Barber's shop
The Journeyman Parson
Outside Inn & Boot-shop
Col. Aberdare
Mr. Tattersall
Hon. G. Ashton
John Beaumont
Hugh Massey
J. Brampton
J. H. Valentine
Unknown
Joseph Cary M.A.
Hon. L. Baxter
"Toddles"
Mr. Craven
Sir Hugh Amherst
Separately, Man on Horseback 1807
Separately, Sir G. A. Jackson
Two Men walking signed "Cheltenham"

Engravings—mostly coloured

3 coloured maps—"Geography Bewitched" or "Droll Caricatures" of
England & Wales, Scotland and Ireland. 1794 (except latter is
undated)
12 mezzotints of the Months of the Year
A book of 12 "Elegant and Humorous Prints of Rural Scenes, adorned
with Comic Figures" printed for Wllm. Allen, 52 Dane St., Dublin,
now in the British Museum
The Vicar and Moses
A Real Scene in St. Paul's Churchyard or A Windy Day

1779

Mr. Wroughton (Surgeon in Bath, acted in Covent Garden & Drury
Lane, Co-Proprietor of Sadler's Wells)

1780

Catch Singers
A London Volunteer
The Contrast (Samuel Johnson)

1782

An Election Scene at Covent Garden

1790 (or 1797)

My Ass in a Bandbox

1792

Lord Loughborough (Chief Justice of the Common Pleas)

1793

A Jack in Office (Mr. Jackson)

1794

The Specious Orator (J. Christie)
Hamlet in Scotland (Stephen Kemble)

1795

A Head of Hare (Captain Hare)
Twelve at Night
Five in the Afternoon
Twelve at Night
Five in the Morning ⎬ The Road to Ruin
A Pair of Spectacles Easily Seen Thro' (Fox & Pitt)

1796

A View of Norfolk (Duke of Norfolk)
Old Quiz (Duke of Queensbury)
Shaw—Shaw (T. Shaw, Violinist)
You must hear that in Rhyme (Joseph Munden)
The Master of the Rolls (Lord Alvanley)
Liberty Hall (Secretary to the Whig Club)

1797

A Great Personage (King of Wurtemburg)
Derby and Joan (12th Earl of Derby & 2nd wife Eliza Farren)
A Chance seller with a capital Prize in a State Lottery
Mrs. Brittle, the beauty of Tunbridge Wells
John Doe and Richard Roe—Brothers-in-law
"Bobby Brush the Phiz-Maker"—self portrait with Book of Heads

1798

A Lawyer and his Agent
Dickie Dangle Dance (The Bath and Tunbridge Wells Guide)
A Chance Seller retired from business (Lord Loughborough)
Members of the Whig Club (D of Norfolk and Charles James Fox)

1799

A Worthy John
We Serve a King Whom we love, a God whom we adore—Pizarro (John
 Kemble)

Hold Pizarro—hear me—Pizarro (Mrs. Siddons as Elvira)
Jane Gibb as she appeared at Bow Street on Thursday Oct. 10th
Ha! am I king, T'is so—but Edward Lives (George Cooke)

1800

James Hadfield, the daring Assassin, who attempted the life of our
 belov'd King at Drury Lane Theatre
Well Neighbour—what's the News?
My dear Girl
A Man of Fashion in 1700—A Fashionable Man in 1800

1801

Brig-General Macdonald
A noble Commander from South Gloucester (Lord Berkeley)
Beau N-sh. What a Flash
A Noble Duke (D. of Grafton)
Martha Gunn (The Old Brighton Bather)
Lord Dashlong Bent on Driving (Lord Sefton)
Sir John, A Dashing Lad—taken on the Steyne at Brighton
A Gloomy Day taken on the Steyne at Brighton (Matthew-Day)
At a Comedy
At a Tragedy
Descriptions of Battles by Sea and Land
A Commander of Light Dragoons (Colonel Affleck)
An Officer of Light Dragoons (Lieut. Fry)
Jack P- the little Admiral (Admiral Payne)
The Pride of all his Friends (Mr. Pride)
A Fashionable Jew Traversing the Steyne at Brighton (? P. Trevor, Sen)

1802

A View near Hyde Park Corner (Mr. Tattersall)
Lord Bishop of St. Asaph The late-Right Revd (Dr. Samuel Horsley)
Mr. Braham in Orlando—To Mr. Thomas Dibdin
The Steward of the Course taken on the Race Ground, Brighton (Sir
 Chas. Bunbury)
A Venerable Peer taken on the Race Course, Brighton (Earl of Clermont)
A benevolent Jew taken on the Royal Exchange (George Goldsmid)
The Little Colonel (General Slade)

1803

Portrait of Robert Dighton Junior in the uniform of the Prince of Wales's
 Volunteers (A Middlesex Volunteers Corps)
My Friend Go To Bed (Mr. Gotobed, a merchant)
The Turf on the Steyne, Brighton (Humphrey Howarth)

Colonel Montgomery, who was unfortunately killed in a duel, April 6th
The Geographical Major (Major Rennie)
The Brighton Guide (Mr. Wade)
The Governor of the Castle at Brighton
Solomon Loan taken on the Royal Exchange
An Old Stump well-known on a Bank
E.P. taken at the Royal Exchange
The Principal Arch of Lambeth Palace (Dr. Moore, Archbishop of Canterbury)

1804

A Great Prince, A Volunteer among the Danes (Col. Prince)
Agamemnon, a Great General (Hew Dalrymple)—taken on the Steyne at Brighton
A Good Old Penn from the Wing of a good old Cock (John Penn)
A Military Inspector (General Jenkinson)
A Low tenant of Lawyal Volunteers (? Mr. Lowton)
A General View of Richmond taken from Sussex (Duke of Richmond)
The Towns-end (Townsend, Bow Street runner)

1806

The Pride of Britain (Prince Regent)
A Hero of the Turf and his Agent (Henry Mellish and Buckle)
Madame Catalini in Semiramide

1807

A View taken from the Townhall Oxford
A View from Trinity College Oxford (Henry Kell)
The Major Part of the Town of Portsmouth (Major Ashurst)
Mother Goose of Oxford (Rebecca Howse)
A View taken from the Swan Brewhouse Oxford (Mr. Hall)
Ireland in Scotland (Mr. Ireland)

1808

Honble Colonel George h--r, Equerry to a Great Personage and Master of a Little Horse (Col. Hanger, Lord Coleraine)
A View taken at Oxford (John Smith)
A Noble Student of Oxford (Lord Nugent—Lord George Grenville)
Dr. Parson, Oxford
A View from Merton Coll. Oxford (Mr. Kilner?)
A View from Magdalen Hall Oxford (Dr. Ford)
A View from Jesus Coll. Oxford (Dr. Hughes)
A View from Brazenose Coll. Oxford (Dr. Cleaver)
A View from Oriel Coll. Oxford (Dr. Eveleigh)
A Celebrated Public Orator (William Crowe)

The Classical Almamater Coachman (Mr. Brobart)
A View from St. Aldgates Oxford (John Grosvenor)
The Father of the Corpn. of Oxford (Omnibus Carus Will Fletcher)
A General View of Old England (Sir Richd England)

1809

A First Rate Man of War—(Admiral Young)
A View from the Pump Room Bath—(Gen. Dankin)
A View from Chatham Row, Bath (Dr. Shepherd)
A View taken from Bladuds Bldgs, Bath (Councillor Morris?)
A View taken from Portland Place, Bath (Mr. Banks)
A View of the Telegraph Cambridge (Dick Vaughan)
A View from St. John's Coll. Cambridge
A View from Magdalene Coll. Cambridge

1810

A View from Baxter's Livery Stables
Sir David Dundas C in C
A Striking View of Richmond (Boxer, Bill Richmond)
Lady of the Lake (Mrs. Billington)
A View from Trinity Coll. Cambridge
George III aged 72
A View from Peter House Cambridge (Dr. Barnes?)

1811

A View of Somerset (Duke of Somerset)
A View of a Temple near Buckingham (George Astwell, Marquess of
 Buckingham)

1812

Molineux (Boxer)
A Gentle Ride from Exeter Coll. to Pimlico (Thos. Clark)
A Master Parson and his Journeyman
A Lawyer and his Client
I Vont take a Farden less—undated

ROBERT DIGHTON JUNIOR

Military Prints and Drawings at Windsor Castle in the Royal Collection
and elsewhere. (See "Military Drawings and Paintings in the Collection
of H.M. The Queen" by A. E. Haswell Miller and N. P. Dawnay.)

DENIS DIGHTON

Paintings and Engravings
Defeat of the Turks at Klissura

Battle of Orthes
Cavalry Skirmishing
Nelson Falling—Nelson Mortally Wounded at Trafalgar
Battle of Waterloo
Death of Nelson
Death of the Son of Prince Platoff
George IV's Coronation Banquet Champion 1821
(See also "Military Drawings and Paintings in the Collection of H.M.
The Queen" by A. E. Haswell Miller and N. P. Dawnay.)

Engravings
1811
Mrs. H. Johnstone in Timour the Tartar

1812
John Bellingham, taken at the Sessions House, Old Bailey, May 15th

1814
Kutusoff (Prince of Smolensk)
Bernadotte
Denis Davidoff the Black Captain
Louis 18th
Tzar Alexander I
Princes Bagration
General Platow
Count Rotopchin
Tschernygscheff

RICHARD DIGHTON

Watercolour Portraits and Drawings
David Dundas
Lord Chesterfield, undated
34 Portrait Drawings of British Officers in the Royal Collection at
 Windsor
John Moore
John Keate

Engravings
Undated
If you'd know who this is, Read (Mr. Read of Doctor's Commons)
"A Kingfisher on the Banks of the Thames"
Mr. W. Farren as Sir Peter Teazle
The Doctor (Mr. James of Magdalen Hall)

A View at Lloyds after a Stormy night
A View of Gloucester (Duke of G.)
A Welch Castle or, Peter the Great Chamberlain of England (Lord Gwydyr)
A View of Holland (Swinton Colthurst H.)
A View in Lothbury (Mr. Lloyd)
Sir Murray Maxwell Kt. CB. a late candidate for Westminster
A View from Trinity Chapel, Cambridge (James Henry Monk)
A Friend in Lombard Street (Thomas Richardson)
No title, or? A Sketch from the Excise (? Ld G. Seymour)
A View on the Stock Exchange (? Mr. Montbart)

1815

A View from Trinity College, Cambridge
A Walk from Bridge Street to St. John's Hall, Cambridge (Isaac Pennington)

1816

A View taken in Oxford
A View taken at Eaton (Dr. Keate)
No title. Half length barrister with ear trumpet

1817

No title. Whole length (? Mr. B. Cohen)
A View from the Horse Guards, or, A General view of Bolton (Gen. Bolton)
A View of Hill near Downshire (Mqs. of Downshire)
Sell and Repent (Mr. Thomas Hall)
A View from the Royal Exchange, or, A Peep into Warnford Court (Lee La Chanette)
No title. Figure writing on wallet (Mr. Ripley)
A View from the Royal Exchange, or, A Portuguese Loan (Nathan Baron Rothschild)
A View from Knightsbridge Barracks, or, A revised edition of Horace (Capt. Sir Horace Seymour)
No title, or, Up-Town (Hon. Arthur Upton)
A View taken in Hyde Park (Marquess of Worcester)

1818

An Illustrious Visiter *(sic)* from Hombourg (Fredk., Prince of Hesse Hombourg)
An Illustrious Consort (Charlotte Augusta, Queen of Wurtemburg)
A Contract (Messrs. Damington and Tremloe)
No title (? Ch. or Hugh Grant) (? A View on the Royal Exchange)

A View from St. James's Street (Earl of Harrowby)
A View of a Lake (Gerard, 1st Viscount Lake)
Mr. Kean as Lucius Junius in Brutus (Edmund Kean)
No title, or, a view on Change (Sir Moses Montefiore)
One of the Rakes of London (Mr. Raikes)
A Good Whip (Earl of Sefton)
A Great Man on Change (Samuel Samuels, often called wrongly
 Thornton and Cohen)
Very like a Whale (? Mr. Hilbers)
Robert Waithman, Esq., or, An Ell wide orator
No title (The Hon. Drummond Barrell, afterwards Lord Willoughby
 d'Eresby)
A View of Yarmouth, or, A View from Yarmouth to Hertford (3rd
 Marquess of Hertford)
The Dandy Club

1819

A Motley Group
His Excellency the Persian Ambassador, or, Mirza Abdul Hassan Khan
Going to White's, or, A spice of Pepper from the stock of Arden (Wm.
 2nd Baron Alvanley)
A View of Argyle (Duke of Argyll)
Kangkook (Sir Hy Fd. Cook)
Mr. Hobhouse, or, A character in the School of Reform (Lord Broughton)
The Golden Ball (Edward Hughes Ball Hughes)
The Hero of the Chase (Col. Joliffe)
The Honble. George Lamb, or, Catallus
Mr. Liston in Love, Law and Physic (John Liston)
A Worthy Alderman of London, or, Why PShaw he's an alderman (Sir
 Jas. Shaw)
The Master General of the Ordinance, or, the best store in the Ordnance
 (Duke of Wellington)
A View in the Justice Room, Guildhall (Sir Matthew Wood)

1820

Byng-Go, or, A Favourite Poodle (Geo. Byng)
Is Camomile a Drug (Mr. Bowden)
Westminster's Story (Sir Francis Burdett)
Queen Caroline as she appeared on the balcony at Alderman Wood's on
 her arrival in England
A Member of the Corporation, or, A Worthy Baronet (Sir Wm. Curtis)
Hudson Gurney, Esq. M.P.
A View of Devonshire (William 6th Duke)
In Prison and ye came unto me (Elizabeth Fry)
An Exotick at the Green House Leadenhall Street (Mr. Gascoigne)

They'll be done, We are obliged to thee (? John Overend)
Orange Boven, or, Halls right (Sir John Hall)
A Big-Whig (Mr. Wombwell)
My Mind's made up (? Mr. Raikes)

1821

A Real T.B. (John Bell)
A Discharged Fife-r, or, A Northern Thane (4th Earl of Fife)
Mr. Charles Kemble as Charles Surface in School for Scandal
Miss M. Tree of Covent Garden Theatre
Miss Wilson in Artaxerxes
William Macready in Richard III
A View of Londonderry, or, A Deceased Statesman (3rd Marquess)
Elegant Manners, or, A Specimen of Good Manners (Chas. 1st Viscount
 Canterbury)
A View from Guildhall to Cannon Street, or, Crying Jimmy (Jacob
 Sims)
Sheriff Double-Hue half Devil half Radical (Robt. Warthman)
A View of Westmoreland, or, An Impression of the Privy Seal or Best
 Blood and Bottom of Westmoreland (John 11th Earl)
A Good Soldier, but no General, or, An old Servant out of Place (Sir
 Robt. Wilson)
Pretty Peter, or, What Joey my boy (? Mr. Hume)

1822

A Princely Ambassador, or, Hazey Weather (Prince Esterhazy)
King Richard. The Broker's Friend (Richard Heals or Heale)
A Thin Piece of Parliament, or, A well-appointed Colonel (Col, Edward
 Lygon)
Mr. Mathews at Home (Charles M.)
No title, or, The But end of a Middlesex Poll (? Sir John Mellish)
The Market Mends (? Mr. Mends)
A View of Nugent, or, A New Gent (Lord Nugent)
A View near Hyde Park Corner (Richard Tattersall II)
A View of Burghersh (11th Earl of Westmorland)
Charley the Principal'd Broker, or, Alspice (Chas. Wright)
No title. Figure to right with hands in pockets
The Wonderful French Giant. Aged 22, 7ft 4in

1823

I believe I'm right (Daniel Alder)
The Mirror of the Times (Thomas Massa Alsager)
Coffee's the thing! Go it ye Tigers (? Hymen Cohen)
A View from the Old South Sea House (Jas. Curtis)

Is Friend Rothschild on 'Change? (? Samuel Gurney)
The Revd. Edward Irving
No title (Mr. Lowe)
A Royal Exchange Consul General (Thos. Rowcroft)
A Near Guess
A View on the Baltic Walk, or, View on the Exchange (Richard Thornton)
A composite Group containing Richd. Thornton and others including Alder, Tooke and Hilbers, all city figures

1824

A View of Beau-Ville (Benjamin Bovill)
A Firm Banker (Mr. Curtis)
Will you let me a loan (Isaac Goldsmid)
A Worthy Alderman of London—(Sir James Shaw)
A View on the Royal Exchange, or, Do you know me? or, Me a Guardian Angel (? Mr. Mee or Richd. Mee Raikes)
No title (? James Lindsey of Lloyds)
The Morning Chronicle (? James Perry; also called MacKenzie)
Write 'em or let 'em alone (Robert Pulsford)
A Stirling Banker (Sir Walter Stirling)
No title (Thomas Wilson)
Mr. Gully of Pontefract, Yorkshire

1825

Samuel Dixon, Esq.
Samuel Favell, Esq.

1826

A View on Cornhill (Bish, lottery contractor)
Lewis and Brighton (Mr. Lewis)

1827

Young Colin (Sir Colin Campbell)
A View of Deerhurst (Lord Coventry)
A Walk from the West End to Lombard Street (Mr. Robarts)
An Opposition Right Honourable (George Tierney)

1828

A Noble Viscount (Henry 3rd Vsct Palmerston)

1856

Sir Charles Merrik Burrell Bart.

* * *

Pomfret undated (McLean's long plate 1825—See Ashmolean Museum)
Tongue Castle (McLean's long plate 1825—See Ashmolean Museum)
A View from Toms (McLean's long plate 1825—See Ashmolean Museum)
A Kick from Yarmouth to Wales
The Amateur of Fashion in the Character of Lothario (Romeo Coates)
A member of one of our Best Boroughs (? Bessborough)
I'll take the particulars—1826
No title (? George Robins)

"The Peep Show."—Watercolour.
See page 10.

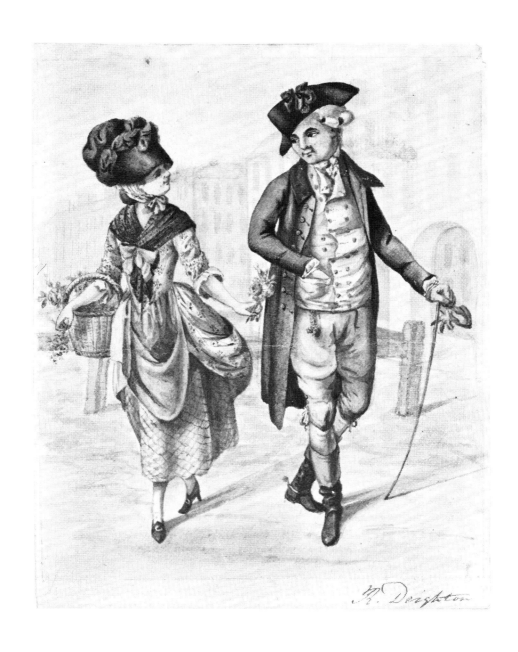

"A Rose-Seller."—Watercolour.
See page 10.

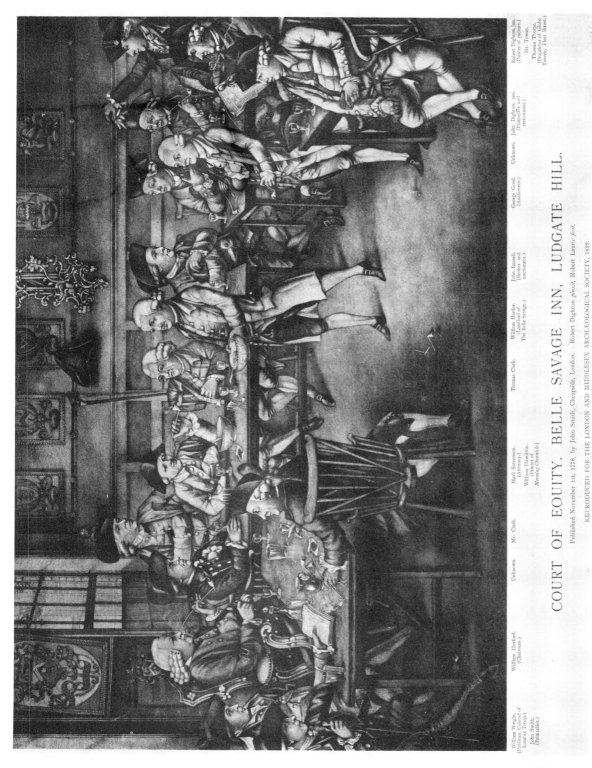

COURT OF EQUITY. BELLE SAVAGE. INN, LUDGATE HILL.

Published November 1st, 1778, by John Smith, Cheapside, London. Robert Dighton *pinxit*, Robert Laurie *fecit*.

REPRODUCED FOR THE LONDON AND MIDDLESEX ARCHÆOLOGICAL SOCIETY, 1899.

William Wright,
(Publican, Colonel of
Leather Troop.)
John Smith,
(Printseller.)

Unknown.

Mr. Clark.

Mark Stevenson.
(Attorney.)
William Hamilton.
(Printer of
Morning Chronicle.)

Thomas Clark.

William Harler.
(Landlord of
The Belle Savage.)

John Russell.
(Broker and
auctioneer.)

George Good.
(Auctioneer.)

Unknown.

John Dighton, sen.
(Printseller and
caricaturist.)

Robert Dighton, jun.
(Painter of picture.)

Mr. Towse.
(Proprietor of Globe
Tavern, Fleet Street.)

Thomas Thorpe,

Court of Equity at the Belle Savage Inn at Ludgate Hill.—Engraving.
See page 20.

47

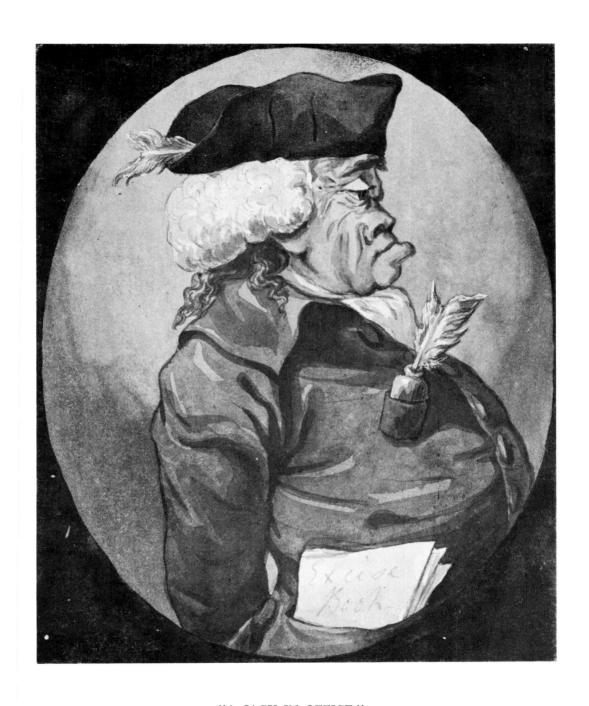

"A JACK IN OFFICE."
Mr. William Jackson—Commissioner for Excise.—
Engraving. *See page* 20.

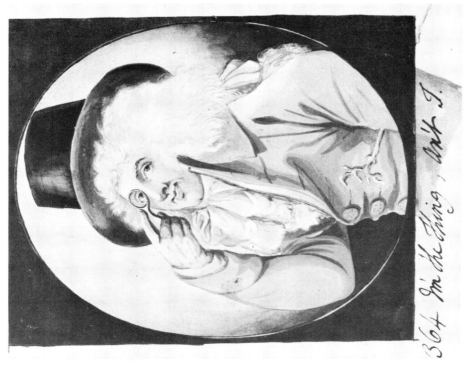

"I'M THE THING AN'T I?"
Self-Portrait of Robert Dighton.—Watercolour.
See page 23.

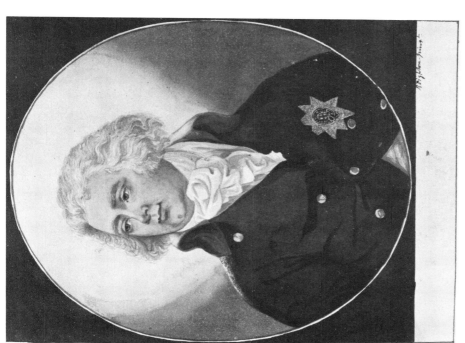

"PORTRAIT OF H.R.H. PRINCE GEORGE,
THE PRINCE REGENT."
Watercolour. *See page 23.*

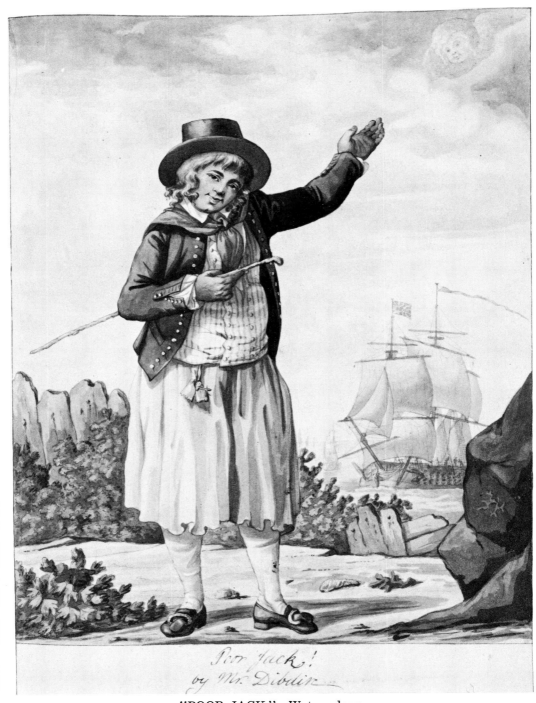

"POOR JACK."—Watercolour.
See page 20.

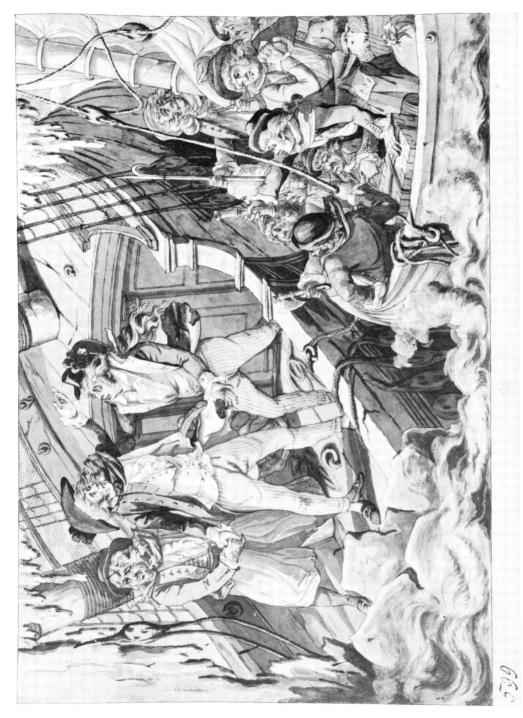

599

"THE PERILOUS SITUATION OF 'THE GUARDIAN' FRIGATE striking the Rocks of Ice." —Watercolour. *See page 14.*

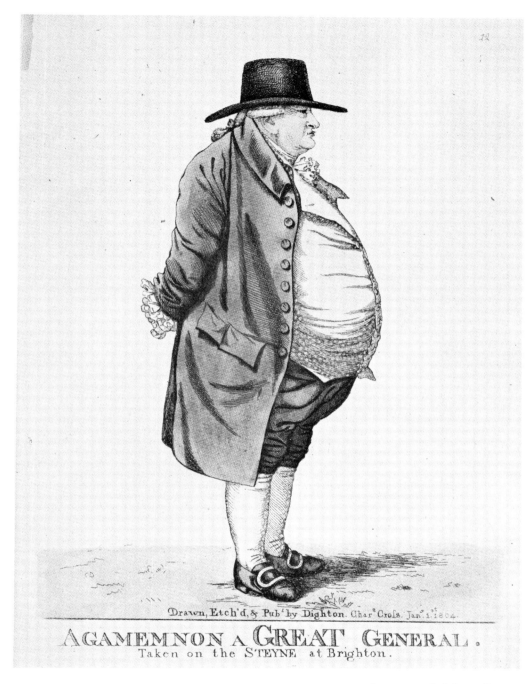

Drawn, Etch'd, & Pub'by Dighton. Char.ᵍ Cross. Jan.ʳ 1ˢᵗ 1804.

AGAMEMNON A GREAT GENERAL.
Taken on the STEYNE at Brighton.

"AGAMEMNON A GREAT GENERAL. Taken on the Steyne at Brighton."
General Sir Hew Dalrymple.—Coloured Engraving.
See page 20.

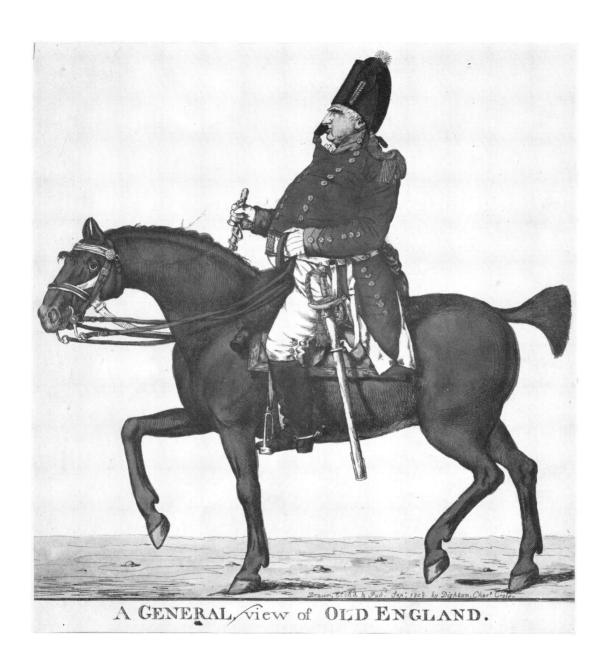

A GENERAL view of OLD ENGLAND.

Drawn, Etch'd, & Pub'. Sep'. 1808. by Dighton, Char'. Cross.

"GENERAL VIEW OF OLD ENGLAND."
General England.—Coloured Engraving.
See page 20.

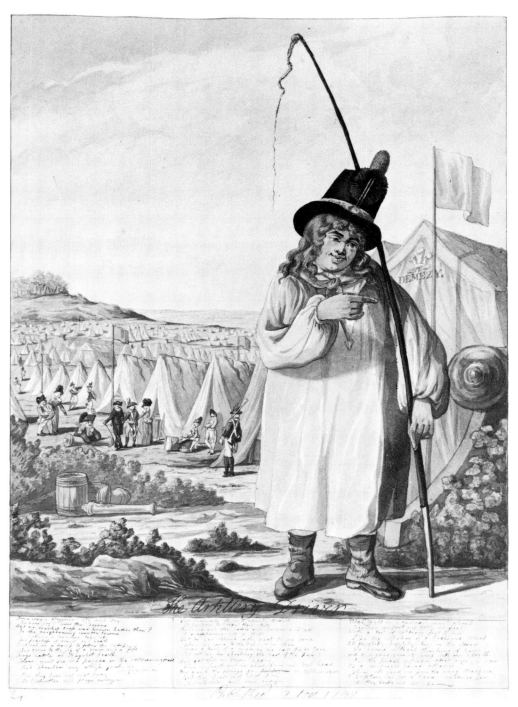

"THE ARTILLERY DRIVER." On Bagshot Heath 1792.—Watercolour.
See page 21.

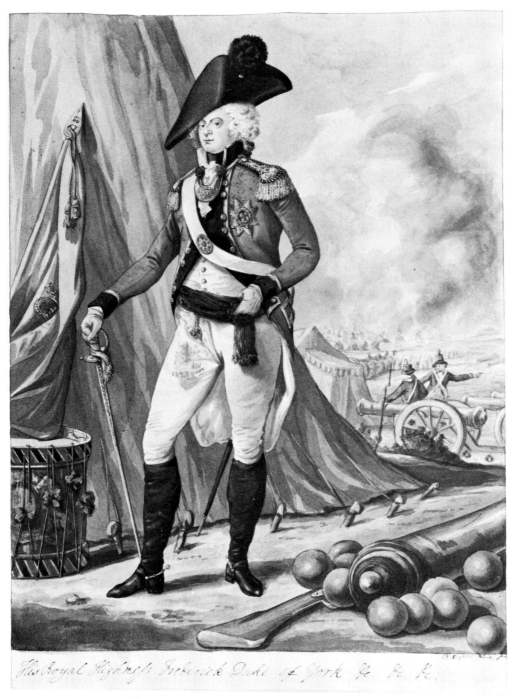

His Royal Highness Frederick Duke of York &c. &c. &c.

"THE DUKE OF YORK."—Watercolour.
See page 23.

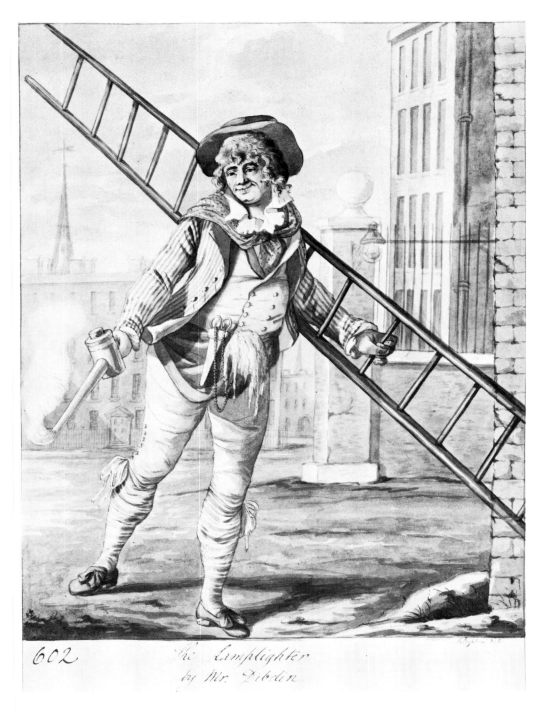

602

The Lamplighter
by Mr. Dibdin

"THE LAMPLIGHTER."—Watercolour.
See page 21.

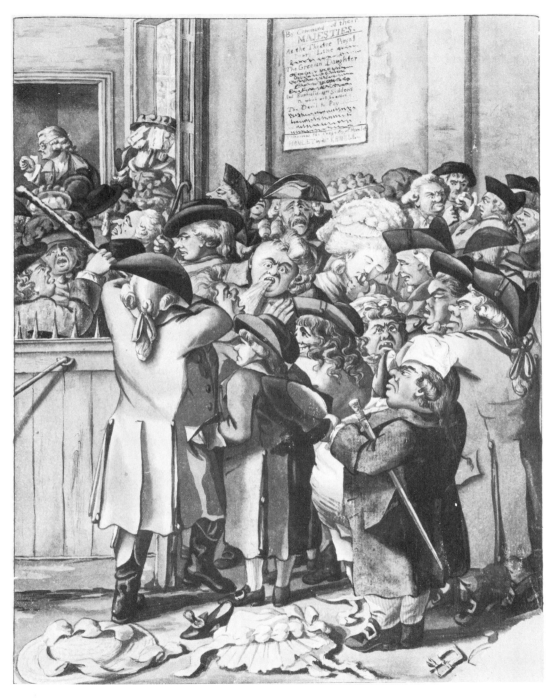

"THE PIT DOOR."—Watercolour.
See page 22.

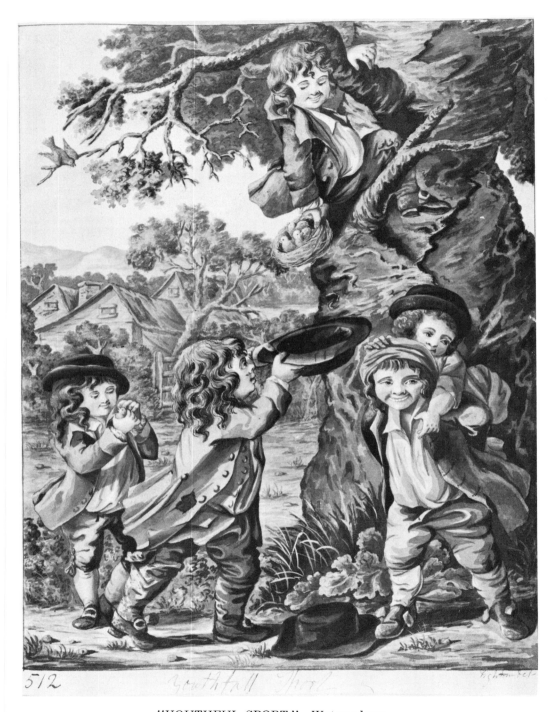

"YOUTHFUL SPORT."—Watercolour.

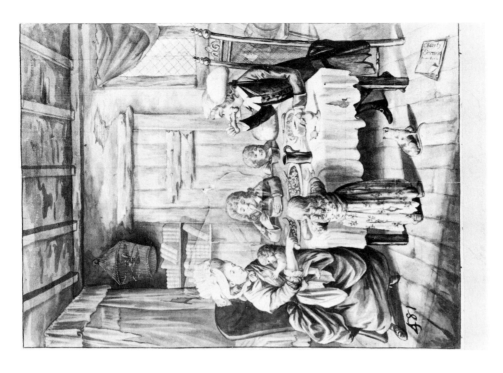

"A JOURNEYMAN PARSON
WITH A BARE EXISTENCE."

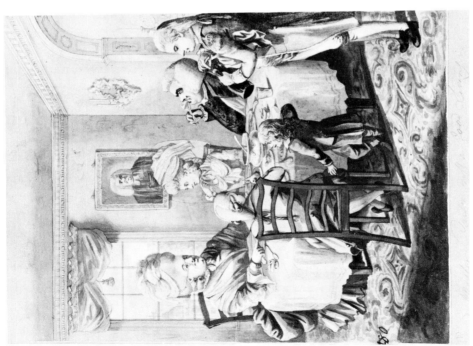

"A MASTER PARSON WITH A GOOD LIVING."
Watercolour

59

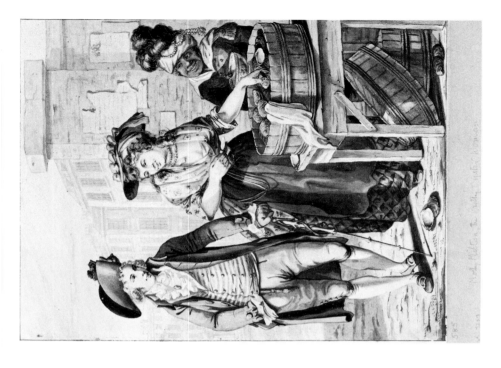

"MOLLY MILTON,
THE PRETTY OYSTER WOMAN."—Watercolour.

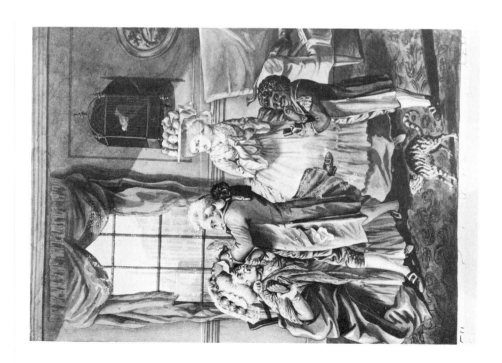

"THE LONDON DENTIST."
—Watercolour.

60

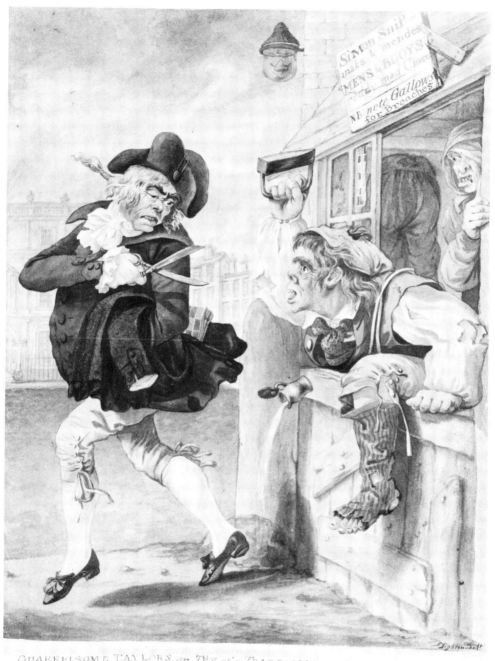

"QUARRELSOME TAILORS, OR, TWO OF A TRADE SELDOM AGREE."
Watercolour.

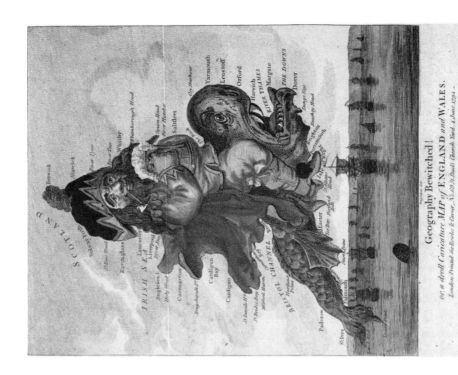

"GEOGRAPHY BEWITCHED."
—Coloured Engravings.
See page 22.

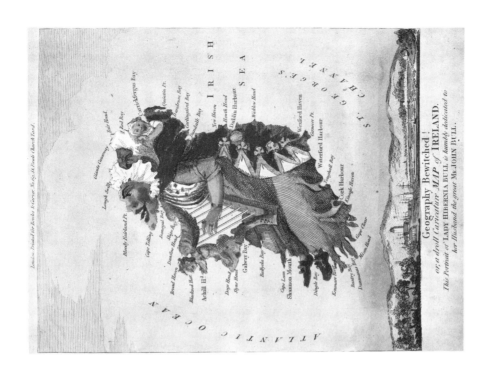

London, Printed for Bowles & Carver, No. 69. St Paul's Church Yard.

ATLANTIC OCEAN

IRISH SEA

ST. GEORGE'S CHANNEL

Giants Causeway · Fair Head · Lough Swilly · Bloody Farland Pt. · Cape Tilling · Donegal Bay · Sligo Bay · Dunfine Head · Broad Haven · Blacksod Bay · Achill Id. · Deyo Head · Sliyo Head · Galway Bay · Bulfocha Bay · Cape Lean · Shannon Mouth · Dingle Bay · Kenmare River · Bantry Bay · Dunmanus Bay · Mizen Head · Cape Clear · Ballycastle Bay · Carrickfergus Bay · Quintin Pt. · Strangford Bay · Carlingford Bay · Dundalk Bay · New Haven · Howth Head · Dublin Harbour · Wicklow Head · Wexford Haven · Carnsore Pt. · Waterford Harbour · Youghall Bay · Cork Harbour · Candys Haven

Geography Bewitched!
or, a droll Caricature MAP of IRELAND.
This Portrait of LADY HIBERNIA BULL, is humbly dedicated to
her Husband, the great Mr. JOHN BULL.

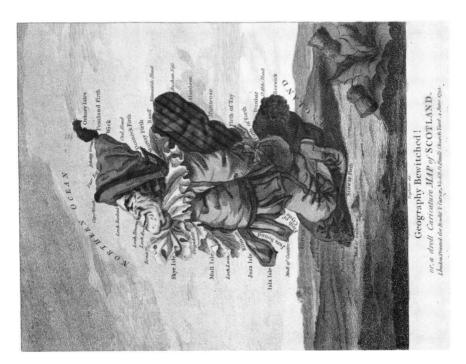

NORTHERN OCEAN

ENGLAND

Orkney Isles · Pentland Firth · Wick · Cape Wrath · Far Id. · Johnny Groats · Loch Rachves · Loch Broom · Loch En · Linth Broom · Orungdale · Skye Isle · Mull Isle · Loch Levin · Kinnard · Jura Isle · Islay Isle · Moll of Cantire · Jura Sound · Fire Spit · Oril Head · Dornoch Firth · Murray Firth · Banff · Buchan Nyss · Gonsistie Head · Aberdeen · Montrose · Firth of Tay · Firth of Forth · Dunbar · St Abbs Head · Berwick · Solway Firth

Geography Bewitched!
or, a droll Caricature MAP of SCOTLAND.
London, Printed for Bowles & Carver, No. 69. St Paul's Church Yard. 1. June 1794.

63

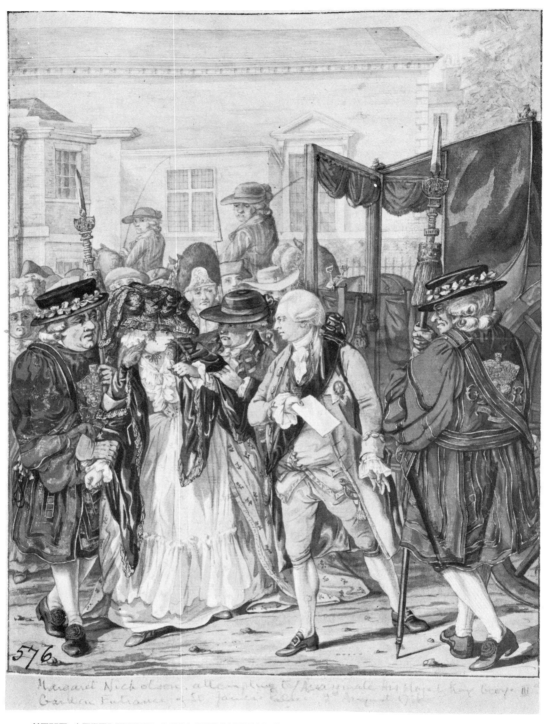

576

Margaret Nicholson, attempting to assassinate his Majesty King George III
Garden Entrance of St. James's Palace 2nd August 1786

"THE ATTEMPTED ASSASSINATION OF GEORGE III on 2nd AUGUST 1786."
At the Garden Entrance to St. James's Palace.—Watercolour.
See page 23.

64

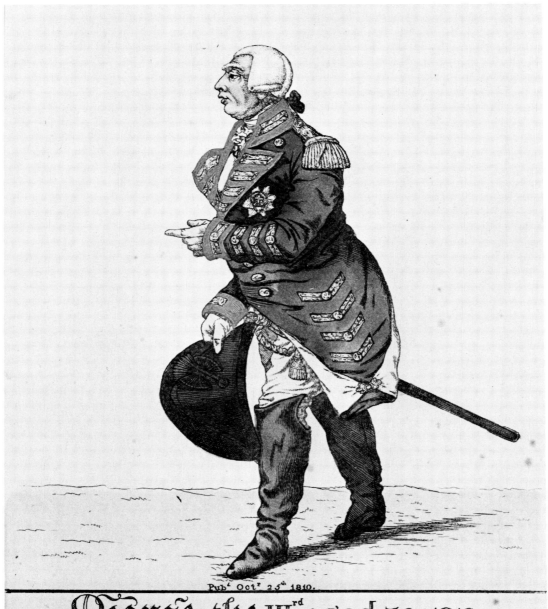

Pubd Octr 25th 1810.

George the-IIIrd aged-72=1810.
REIGN'D-50-Years. A ROYAL JUBILEE.
Taken at Windsor by R Dighton, Spring Gardens.

"GEORGE III—aged 72—Jubilee Year 1810."—Coloured Engraving.
(Courtesy of The Royal Pavilion, Art Gallery and Museums, Brighton.)
See page 23.

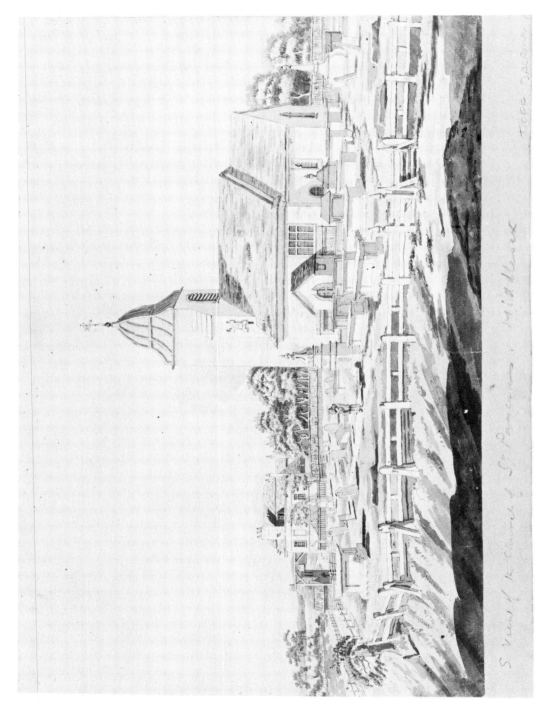

"A SOUTH VIEW OF THE CHURCH OF ST. PANCRAS IN THE COUNTY OF MIDDLESEX."
—Watercolour. *See page 25.*

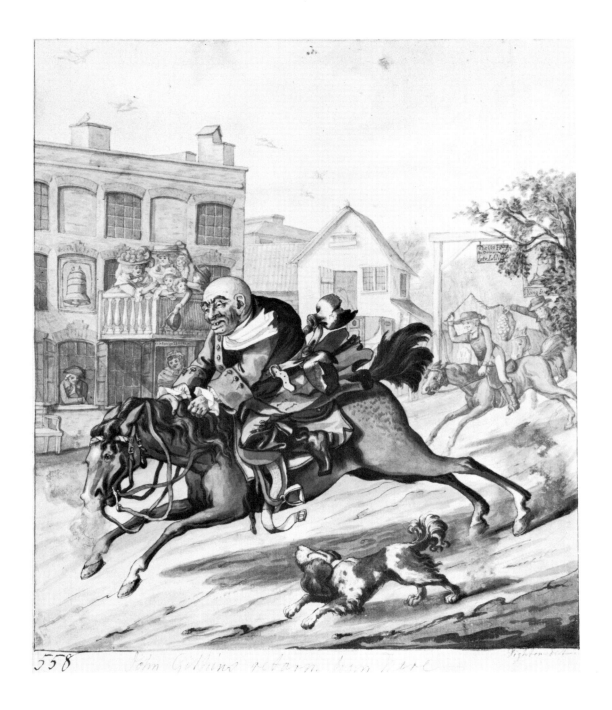

"JOHN GILPIN'S RETURN FROM WARE."—Watercolour.
See page 24.

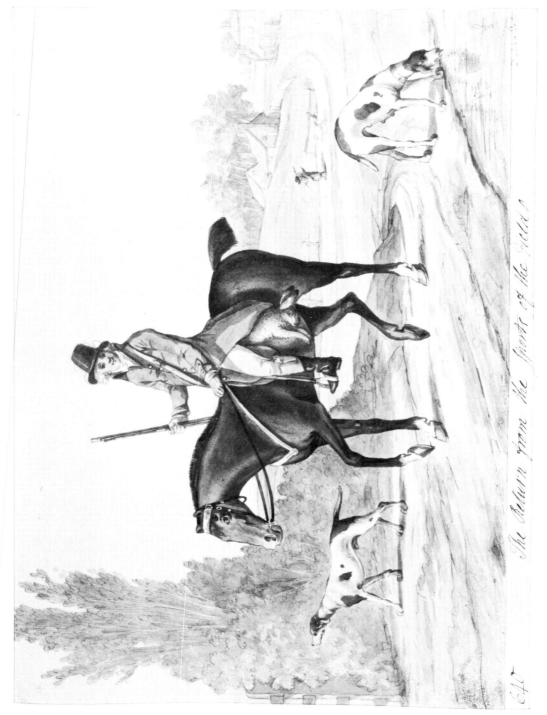

The Return from the Sports of the Field

"THE RETURN FROM THE SPORTS OF THE FIELD."—Watercolour.

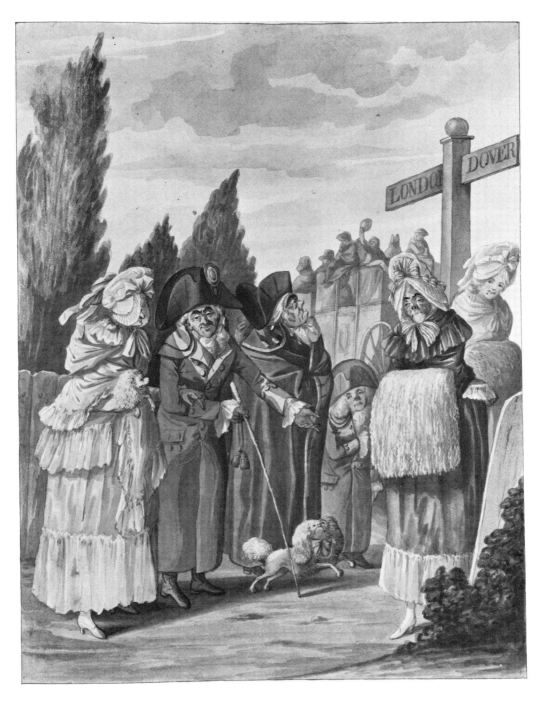

"FRENCH PRIVATEERS CRUISING IN THE CHANNEL."—Watercolour.
See page 23.

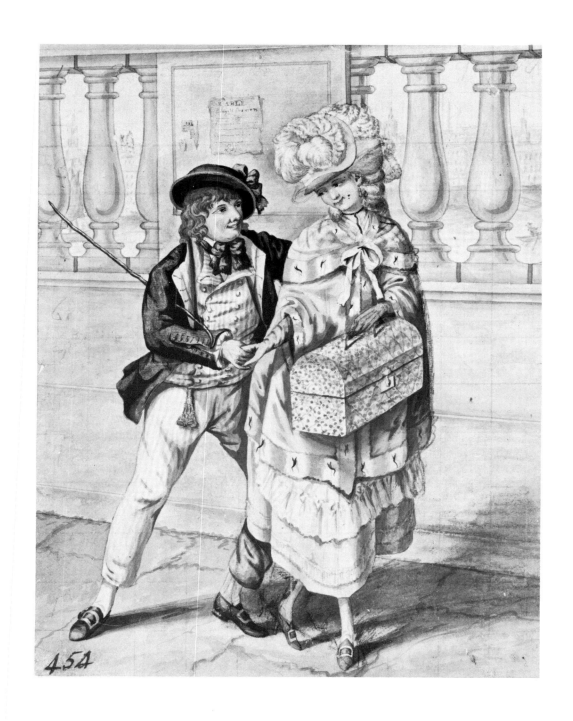

"AN ENGLISH MAN OF WAR TAKING A FRENCH PRIVATEER."
On London Bridge.—Watercolour.

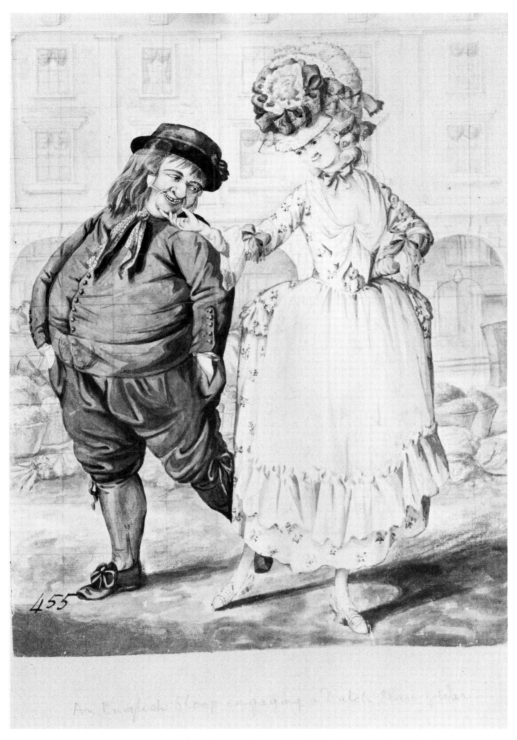

"AN ENGLISH SLOOP ENGAGING A DUTCH MAN OF WAR."
In the Piazza, Covent Garden.—Watercolour.

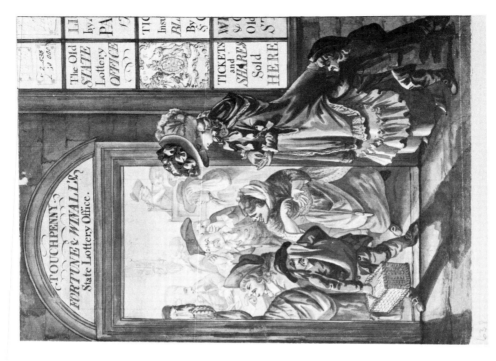

"THE LOTTERY CONTRAST."—Watercolour.

"FATHER PAUL IN HIS CUPS—OR THE PRIVATE
DEVOTIONS OF A CONVENT."—Watercolour.
See page 24.

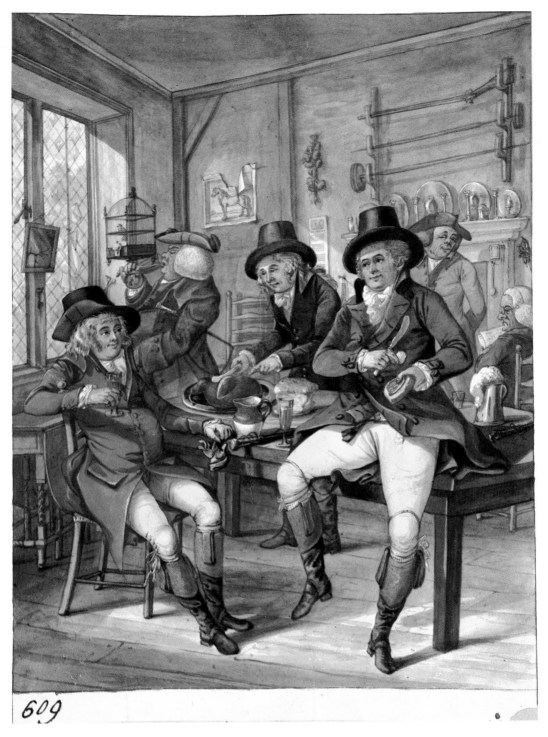

609

"BACHELOR'S HALL."—Watercolour.
See page 21.

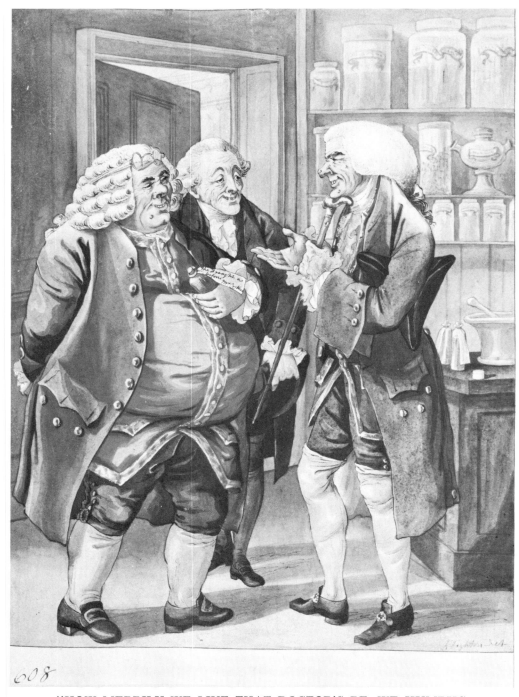

"HOW MERRILY WE LIVE THAT DOCTOR'S BE, WE HUMBUG
THE PUBLIC AND POCKET THE FEE."—Watercolour.

74

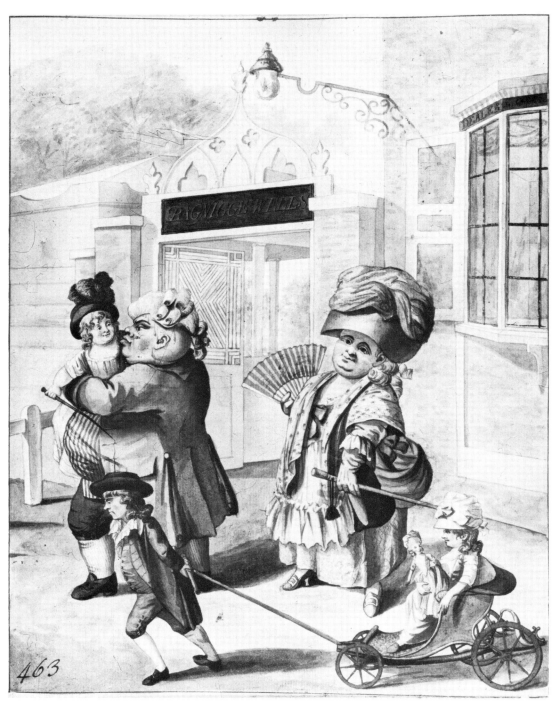

"MR. DEPUTY DUMPLING AND FAMILY ENJOYING
A SUMMER AFTERNOON."—Watercolour.
See page 24.

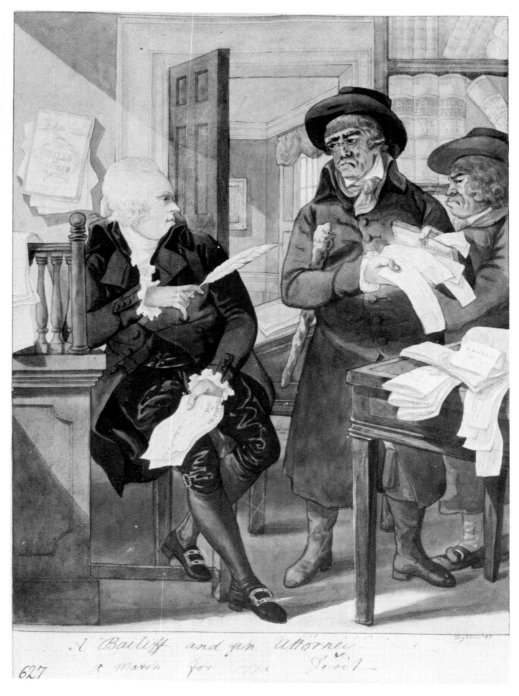

"A BAILIFF AND AN ATTORNEY—A MATCH FOR
THE DEVIL."—Watercolour.

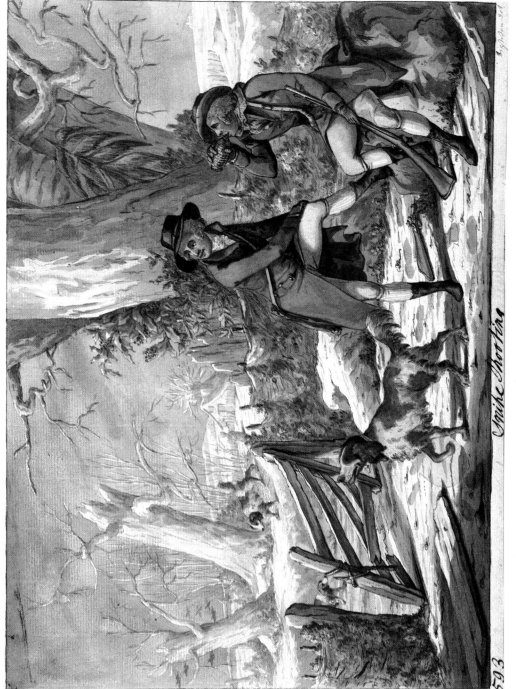

Snipe Shooting

593

"SNIPE SHOOTING" (One of a pair to "Pheasant Shooting").—Watercolour.

77

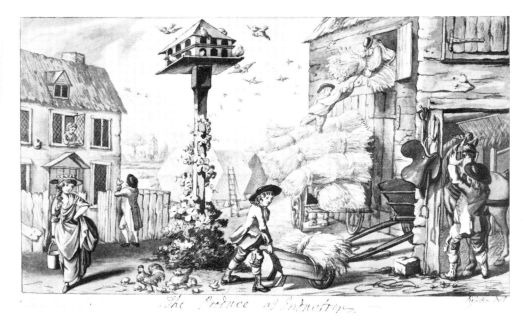

"THE PRODUCE OF INDUSTRY."—Watercolour.

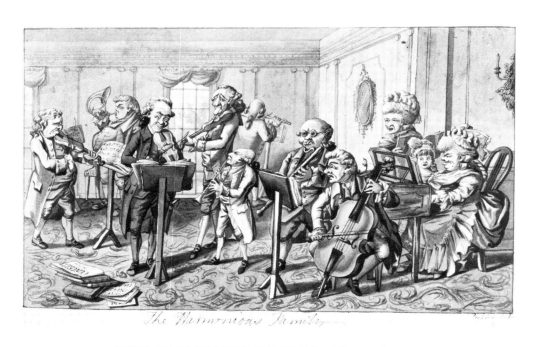

"THE HARMONIOUS FAMILY."—Watercolour.

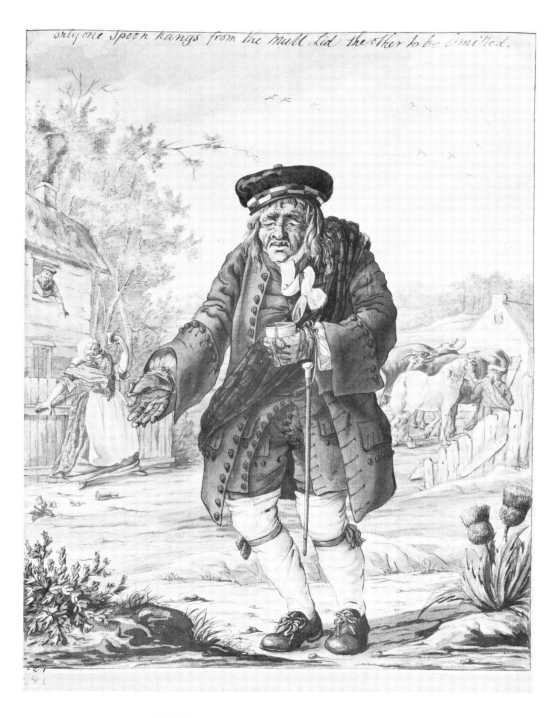

only one spoon hangs from the mull lid the other to be Omitted

"HOOLY AND FAIRLY."—Watercolour.
See page 24.

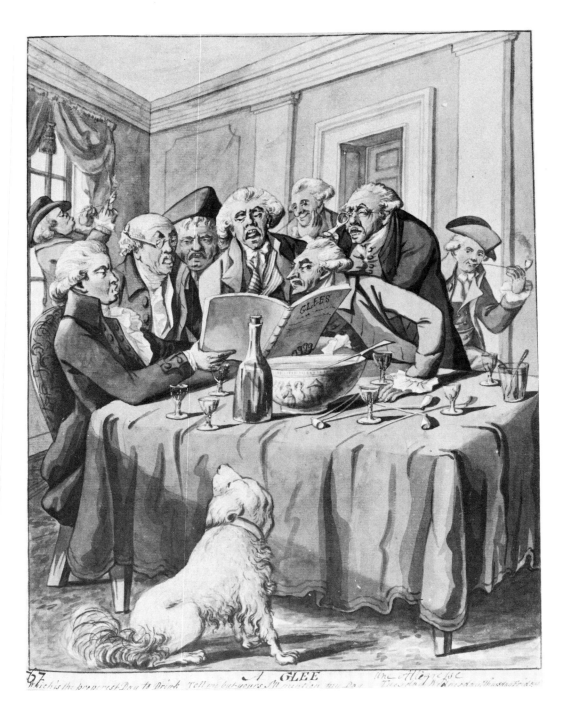

"A GLEE. UNE ALLÉGRESSE."—Watercolour.
See page 23.

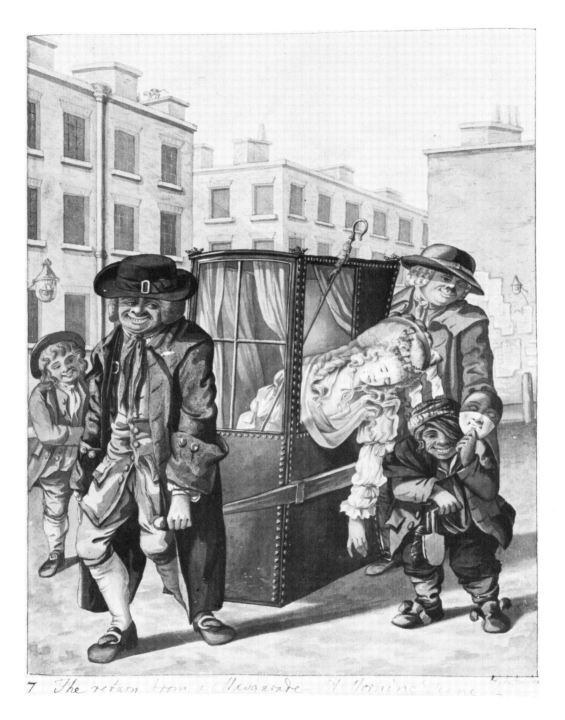

7 The return from a Masquerade A Morning Scene

"THE RETURN FROM A MASQUERADE—A MORNING SCENE."
Watercolour. *See page* 24.

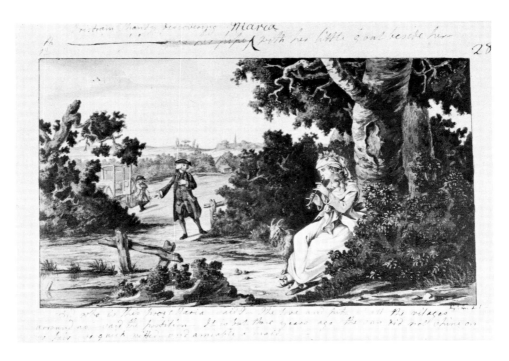

"TRISTRAM SHANDY DISCOVERING MARIA."—Watercolour.

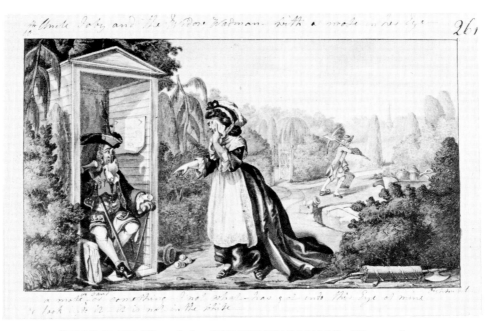

"UNCLE TOBY and the WIDOW WADMAN."—Watercolour.

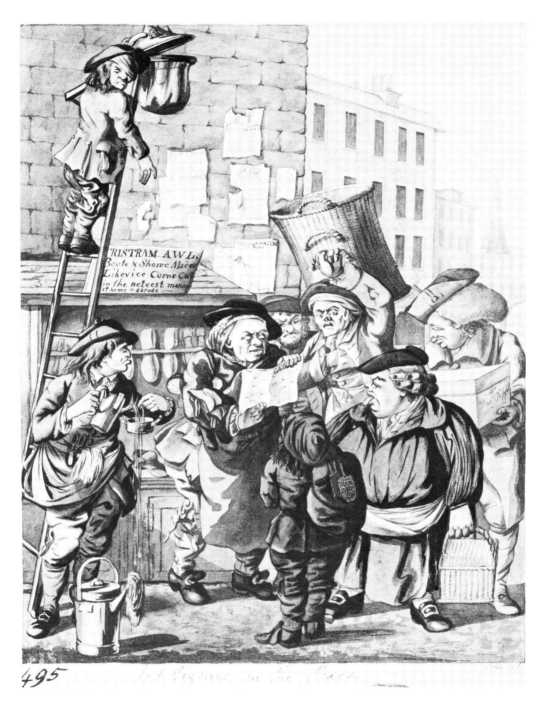

"INTELLIGENCE ON THE PEACE."—Watercolour.
See page 21.

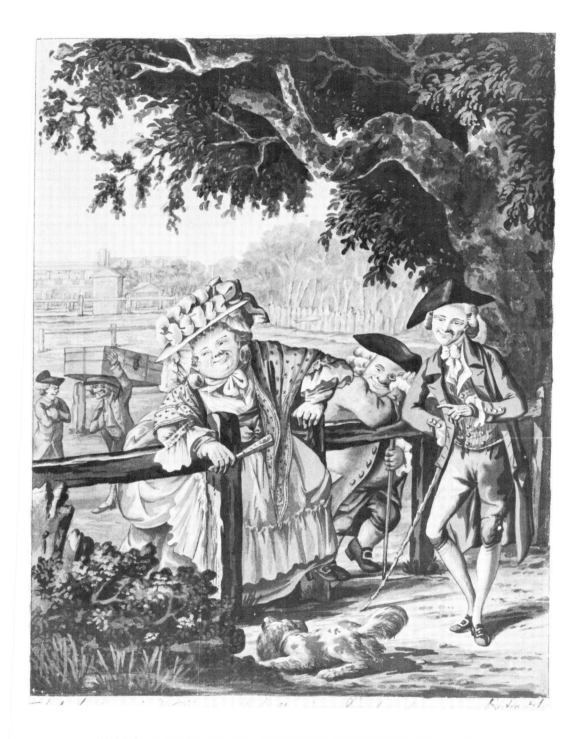

"LABOUR IN VAIN—OR, FATTY IN DISTRESS."—Watercolour.

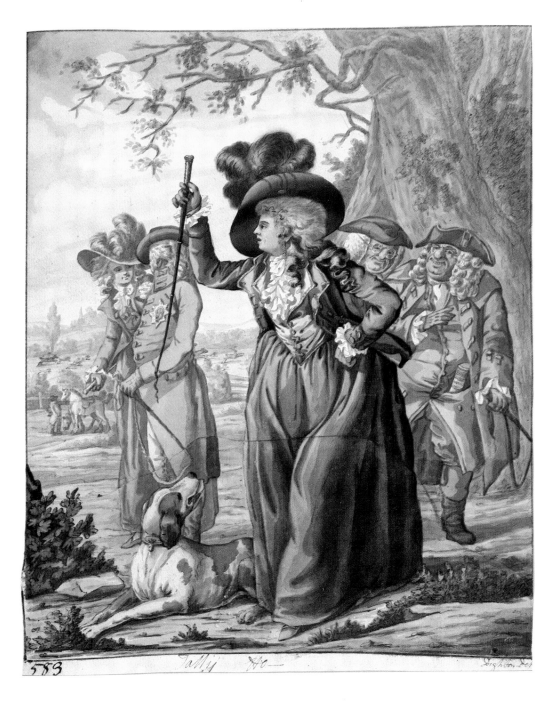

"TALLY HO."—Watercolour.
The man with face averted and wearing the Garter Star is possibly the
Prince of Wales.

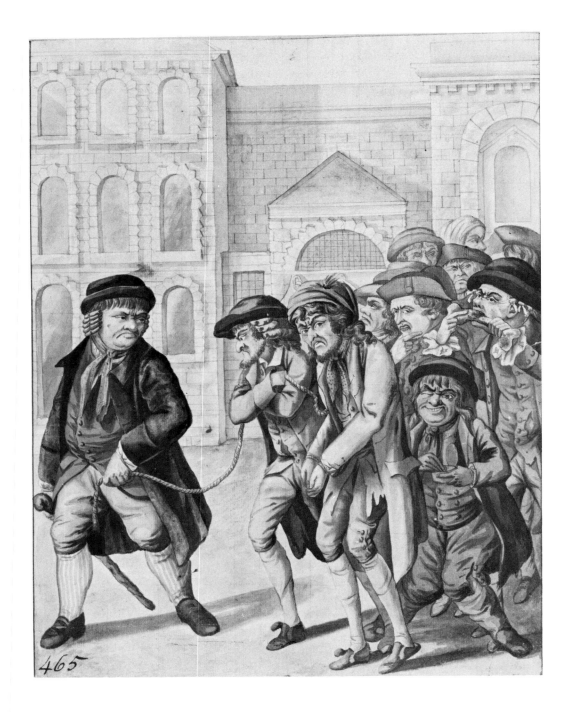

"A FLEET OF TRANSPORTS UNDER CONVOY."—Watercolour.
See page 24.

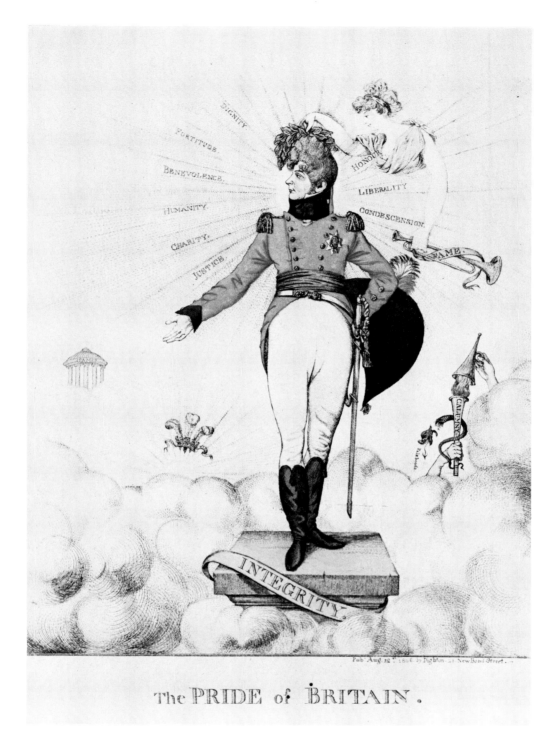

The PRIDE of BRITAIN.

"THE PRIDE OF BRITAIN (The Prince of Wales) 1806."—Coloured Engraving.
(Courtesy of The Royal Pavilion, Art Gallery and Museums, Brighton.)

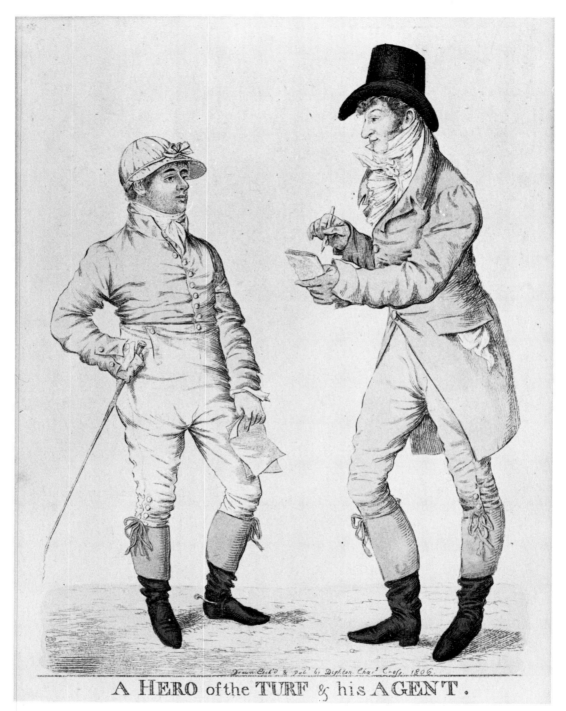

A HERO of the TURF & his AGENT.

"A HERO OF THE TURF AND HIS AGENT. 1806."
(Col. Henry Mellish and jockey Buckle.)—Coloured Engraving.
(Courtesy of The Royal Pavilion, Art Gallery and Museums, Brighton.)

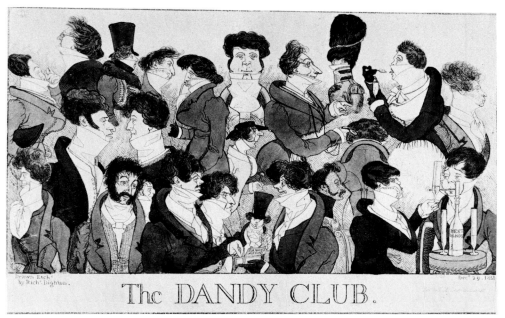

"THE DANDY CLUB." 1818.

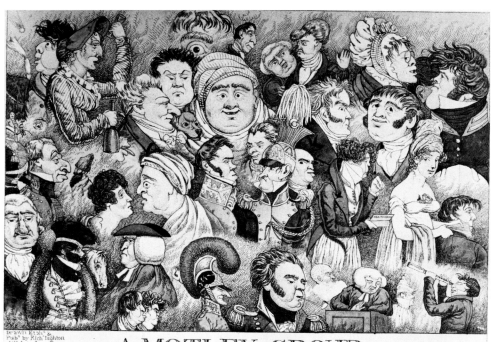

"A MOTLEY GROUP." 1819.
Coloured Engravings by RICHARD DIGHTON.
(Courtesy of The Royal Pavilion, Art Gallery and Museums, Brighton.)

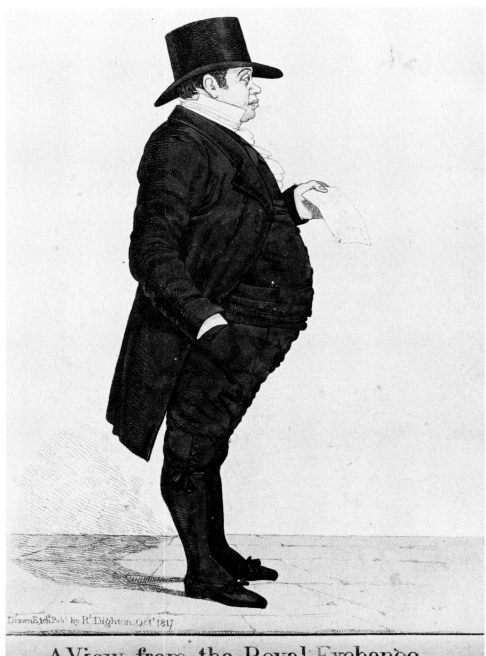

A View from the Royal Exchange.

"A VIEW FROM THE ROYAL EXCHANGE." (Nathan, Baron Rothschild) 1817
Coloured Engraving by RICHARD DIGHTON.
(Courtesy of The Royal Pavilion, Art Gallery and Museums, Brighton.)

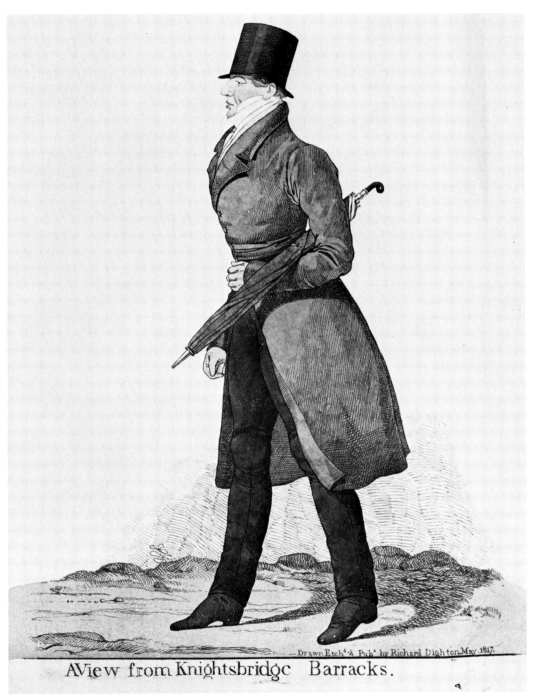

A VIEW FROM KNIGHTSBRIDGE BARRACKS (Capt. Sir Horace Seymour).
Coloured Engraving by RICHARD DIGHTON.
(Courtesy of the Royal Pavilion, Art Gallery and Museums, Brighton.)

GEORGE IV's CORONATION BANQUET CHAMPION 1821
Watercolour by DENIS DIGHTON.
REPRODUCED BY GRACIOUS PERMISSION OF HER MAJESTY THE QUEEN.

MUSEUMS AND ARCHIVES, ETC.

The Royal Library, Windsor Castle
The Ashmolean Museum, Oxford
Belvoir Castle
The British Museum
City Art Gallery, Manchester
City of London Club
City Museum and Art Gallery, Birmingham
The Collection of the Duke of Brunswick at Marienburg
The Finsbury Library
The Fitzwilliam Museum, Cambridge
The Garrick Club
The Guildhall Library
The Mellon Foundation, U.S.A.
The Museum of London
The National Army Museum
The National Gallery of Scotland
The National Maritime Museum, Greenwich
The National Portrait Gallery, London
Newport Art Gallery
Nottingham Museum
The Royal Pavilion, Art Gallery and Museums, Brighton
Sadler's Wells Library
Victoria and Albert Museum
The Westminster Library
The Witt Library, Courtauld Institute (Photos)

SELECTED BIBLIOGRAPHY

Benezit—Dict. of Painters, Sculptors, Designers & Engravers

Nagler's—Kunstler—Lexicon 1835

Veth—Comic Art in England, p. 4

Gentleman's Magazine—Aug. 1814, p. 193

Dictionary of National Biography

A Dictionary of British Military Painters—Arnold Wilson (F. Lewis, Publishers Ltd.) 1972

Sadler's Wells—Prints, Songs, Playbills, etc.—Sadler's Wells Library

The Print Collector's Quarterly—April 1926—Vol. 13 No. 2 by Henry M. Hake

History of Engravings and Etching from 15C.–1914, p. 237, by Arthur Hind

Harry R. Beard Theatre Collection

The Field—Dec. 30 1926—"The Dightons" by Bickerstaffe

Illustrated London News—Aug. 22 1931 (British Sports)

Apollo—Aug. 1931, The Watercolours of Robert Dighton—R. Edwards

English Drawings of the Stuart and Georgian periods in the Collection of H.M. The King at Windsor Castle—A. P. Oppé—Phaidon Press 1950

The Connoisseur—Nov. 1903, pp. 187–8, Nov. 1904, pp. 172–182, articles by Joseph Grego

The Connoisseur—Nov. 1906, p. 231, Robert and Richard Dighton, Portrait Etchers by D. C. Calthorp

The Connoisseur—Aug. 1953, p. 59—Humorous Mezzotints

The Connoisseur—Dec. 1967, pp. 237–241 by Adrian Bury

Military Drawings and Paintings in the Collection of H.M. The Queen at Windsor Castle—A. E. Haswell Miller & N. P. Dawnay—Phaidon Press 1966 & 1970

Catalogue of the Political and Personal Satires, British Museum—M. D. George

Sotheby's Catalogue dated 23rd February 1978

Bryan's Dictionary of Painters and Engravers